JN101627

神社仏閣

SHINTO SHRINES AND
BUDDHIST TEMPLES

TOKYO ARTRIP

はじめに

東京の街を、日本のカルチャーを切り口に遊ぶ、アート＆デザインラバーのためのガイドブックシリーズ「TOKYO ARTRIP」。テーマに合わせたスペシャリストたちに聞いた、とっておきの場所や遊び方を紹介する。神社仏閣がテーマの本書は、東京国立博物館の皿井舞さん（PART_1）、建築家の福島加津也さん（PART_2）、スウェーデン出身、庭師の村雨辰剛さん（PART_3）、「TOKYO ARTRIP」編集チーム（PART_4）が登場。仏像や日本美術を鑑賞、建築・都市論の切り口で眺める、庭を愛で歴史を識る、エンターテイメントな要素も楽しむ。それぞれの専門分野の視点から、東京ならではの神社仏閣の魅力を紹介する。知識欲を満たすため、また、日常の楽しみを求めて気軽に神社仏閣へ出かける、そんなきっかけになる一冊だ。

Introduction

TOKYO ARTRIP is a series of guidebooks about Tokyo. The unique locations introduced in each edition are selected from the perspective of Japanese culture, art and design. Several ARTRIP advisors appear in each edition. In this volume on Shinto shrines and Buddhist temples, the following four advisors will show you around the city: Mai Sarai of Tokyo National Museum (Part_1), architect Katsuya Fukushima (Part_2), Swedish gardener Tatsumasa Murasame (Part_3), and the TOKYO ARTRIP editorial team (Part_4). Our goal is to introduce readers to the world of shrines and temples through a variety of lenses. Whether it's the beautiful Japanese art and Buddhist statues that reside within them, the architecture and garden design, or the sense of history each shrine and temple bestow upon its visitors, you're sure to find something that intrigues you. We hope this little guide helps readers to understand more about Shinto shrines and Buddhist temples and to enjoy them as an accessible part of their everyday life.

この写真は、「深大寺」(p.10) の水舎のある風景です。
Purification fountain at Jindaiji Temple (p.10)

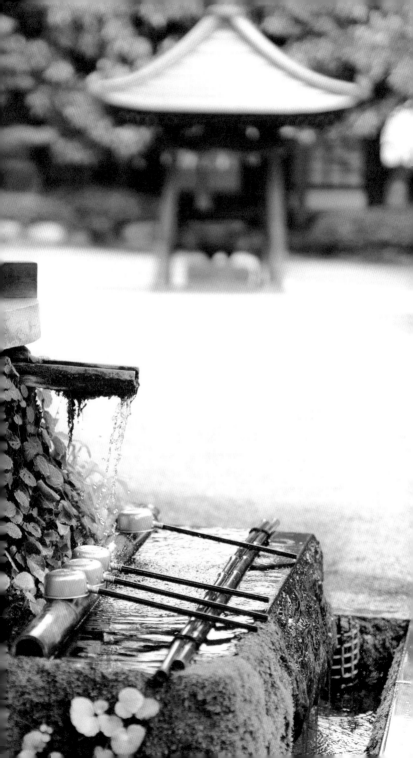

目次

アイコンの説明 （時）開館時間 （料）入館料等 （電）電話番号 （休）定休日 （住）住所 （ア）アクセス
（ウ）ウェブサイト　　　　　　　　　　　　　　　　　　※特に記述のないものは、税込になります。
※本書に掲載の内容は、2020年7月現在の情報に基づいたものになります。状況により情報が変更になる
　ことがありますので、お出かけの際には、事前に神社仏閣のホームページなどでご確認ください。

CONTENTS

Icon Description Ⓗ Hours of Operation Ⓕ Fee Ⓣ Telephone Number Ⓒ Closed Days
Ⓐⓓ Address Ⓐⓒ Access Ⓤ URL

※ All prices are tax-inclusive, otherwise stated.
※ All information contained in this book are as of July, 2020.
Please check the websites etc. as information may change.

PART_1

仏像・日本美術を鑑賞する

**BUDDHIST STATUES AND
JAPANESE ART**

飛鳥時代の昔から、くにの安泰や
生活の安寧を祈ってきた仏尊の造形に出会う

仏教美術を専門として、さまざまな展覧会企画に携わる皿井さん。
「東京では非公開の寺院が多いので、ご尊像を拝観することのでき
るお寺にはぜひ足を運びたいですね」と、ナビゲートしてくれた。「ま
ずは、東京都で唯一の国宝の仏像がお祀りされている深大寺。飛鳥
時代後期の金銅仏、如来倚坐像は微笑みをたたえた優しいお顔つき
をされています。高幡不動尊には、平安後期の巨大なお不動さんが
いらっしゃいます。迫力に圧倒されつつ、悪いものから守ってくれ
る安心感も。塩船観音寺には、鎌倉時代の仏師の気迫に満ちた尊像
群が残ります」。江戸時代にフォーカスされがちな東京にもその前
史があり、ちょっと足を延ばせば、積み重ねられてきた歴史の重層
性を感じさせる仏像たちに出会うことができるという。

The Buddhas who Prayed for Peace and Tranquility since the Asuka Period

Mai Sarai specializes in Buddhist art and has helped arrange exhibits at
many art exhibitions. "Many temples in Tokyo are closed to the public,
so you really want to visit the ones that are open where you can see
Buddhist statues. First, there is Jindaiji Temple, home to the one and
only Buddhist statue in Tokyo that is a National Treasure. This bronze
Buddha from the late Asuka period is in a seated position, with a gentle
smile. At Takahata Fudoson Kongoji Temple, you can see a huge Fudo
Myo-o statue from the late Heian period. The sheer power of this
statue can be at once frightening and comforting, knowing that Fudo-
san will protect us from evil. Shiofune Kannonji Temple is also home
to a selection of statues that show the incredible vigor of Kamakura
sculptors." Though Tokyo is not known for its pre-Edo history, if you
know where to look, you can experience the city's long and multi-layered
history through these fascinating Buddhist statues.

ARTRIP ADVISER	東京国立博物館学芸研究部平常展調整室長。京都府生まれ。京都大学大学院博士後期課程修了。博士（文学）。東京文化財研究所主任研究員、東京国立博物館主任研究員を経て現職。専門は仏教美術史。
皿井舞さん Mai Sarai	Chief Curator, Tokyo National Museum, Liberal Arts Research Division. Head of Art Loan Promotion Workshop at Center for the Utilization of Cultural Assets. PhD in Literature, and served as chief researcher at the Tokyo Cultural Assets Research Institute and the Tokyo National Museum.

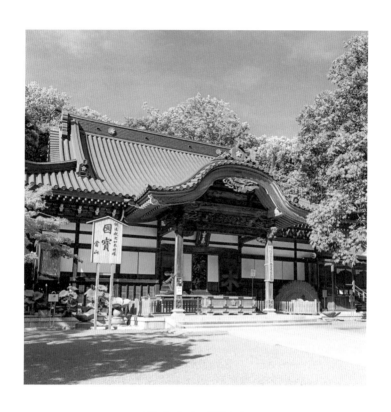

❶ 深大寺（調布）

参道の店々が開き始める朝、山門をくぐり境内に入ると、水路を走るせせらぎの音と緑と諸堂の一体感に心が洗われる。「山門が開く早朝は朝靄で一面真っ白、おすすめです」とお寺の櫻井圓晋さん。こんこんと湧き出る水の豊かさをみれば、古来、信仰を集めて町が成った理由、そして門前にひしめく蕎麦屋、隣接した植物園のバラの美しさにも合点がいく。733（天平5）年創建のこの古刹でまず拝見したいのは、釈迦如来像（p.11）。東日本最古で、都内で唯一寺院が有する国宝仏だ。このお像は、実は、寺では長らく忘れ去られていた。江戸時代に火災で諸堂が焼失した後、いち早く再建された元三大師堂の裏に放置され、再発見されたのは明治時代に入ってからだとか。白鳳時代という美称のある飛鳥時代7世紀後半に、銅を鋳造して造られた、日本人好みともいえる柔らかな微笑みをたたえるご尊顔は、釈迦堂で拝観時間にいつでも拝むことができる。

� 9:00 〜 17:00。釈迦堂は 10:00 〜 16:00 ㊎ 釈迦堂 300 円 �电 042-486-5511 ㊡ 無休 ㊣ 調布市深大寺元町 5-15-1 ㋐ 京王線調布駅よりバス「深大寺小学校前」徒歩 5 分・つつじヶ丘駅よりバス「深大寺」徒歩 1 分 ㋑ jindaiji.or.jp

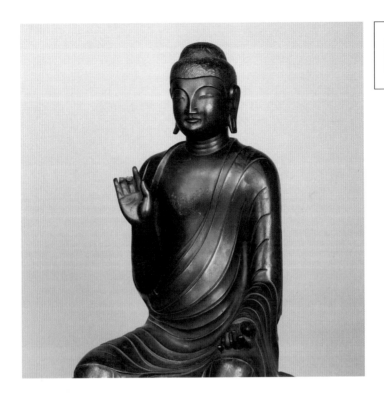

● JINDAIJI TEMPLE (Chofu)

Walk up the *sando* in the early morning and you'll hear the soft murmuring of the stream. "In the early morning just when the gates open, the morning mist forms a carpet of sheer white that I recommend everyone to see," says Enshin Sakurai, who serves at the temple. When you see the bountiful waters that flow here, it's easy to understand why this area became a spiritual hub and the perfect place for a soba shop and rose garden. The first thing you will want to see when you visit this temple dating back to the year 733 is the oldest National Treasure Buddha statue in East Japan. This Shaka Nyorai statue (p.11) was actually forgotten as the principle object of worship at the temple for a time. After a fire destroyed the temple in the Edo period, it was placed in the back of Ganzan Daishi Hall, only to be rediscovered in the Meiji period. There is another statue worth noting in the Shakado Hall, a Hakuho-era work whose striking features are beloved by the Japanese.

(H) 9:00~17:00 / Shakado Hall 10:00~16:00 (F) Shakado Hall ¥300 (T) 042-486-5511 (C) Open Year-round (Ad) 5-15-1 Jindaiji Motomachi, Chofu City (Ac) Chofu Station (Keio Line)-Jindaiji Elementary School (bus) then 5-min walk, Tsutsujigaoka Station-Jindaiji Temple (bus) then 1-min walk (U) jindaiji.or.jp

境域が清水に恵まれる深大寺は、奈良時代に水神の深沙大王（じんじゃだいおう）を祀る寺として開かれた。平安時代に天台宗となり、元三大師（がんざんだいし）像を奉安した。現在寺に伝えられる元三大師像（都指定有形文化財）は、鎌倉時代から南北朝時代にかけて再興された像。源氏からの信仰を集めて関東一の密教寺院として隆盛を極めた。今も元三大師堂では厄や災いを祓う迫力ある護摩祈願が毎日行われている（3000円〜、平日2回土日祝日3回受付、特別行事期間には例外あり）。

Jindaiji, blessed with clear spring waters, began in ancient times as a temple gave thanks to the bountiful springs and worshipped the god of water, Jinja Daio. The temple was converted to the Tendai sect of Buddhism during the Heian period, and the Ganzan Daishi statue (Designated Tangible Cultural Property) was enshrined at this time. The temple was patronized by the Minamoto family and flourished as the greatest Buddhist temple of esoteric teachings in the Kanto region. To this day, special Goma Kigan prayers are given daily in the Ganzan Daishi Hall to expel misfortune and calamity (¥3,000~, twice per day on weekdays, 3 times on weekends and holidays).

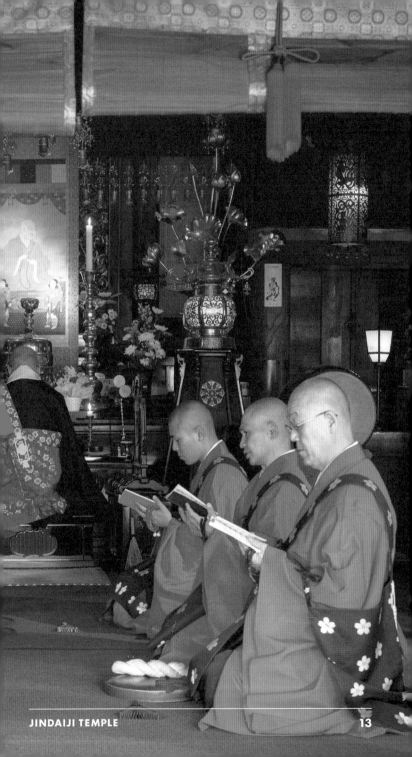

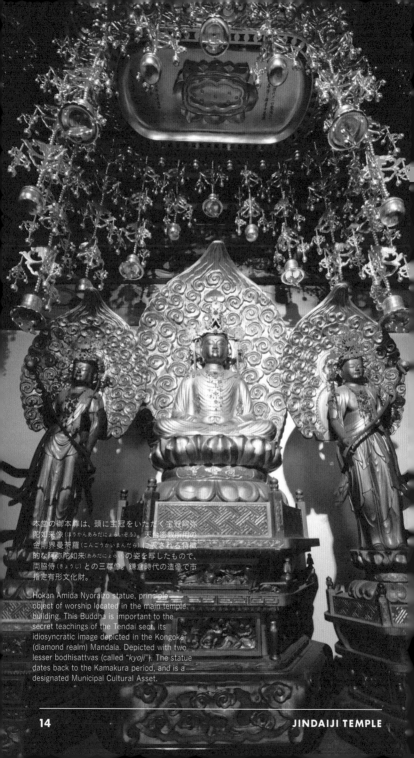

本堂の御本尊は、頭に宝冠をいただく宝冠阿弥陀如来像（ほうかんあみだにょらいぞう）。天台密教所用の金剛界曼荼羅（こんごうかいまんだら）に愛される特徴的な阿弥陀如来（あみだにょらい）の姿を写したもので、両脇侍（きょうじ）との三尊像。鎌倉時代の造像で市指定有形文化財。

Hokan Amida Nyoraizo statue, principle object of worship located in the main temple building. This Buddha is important to the secret teachings of the Tendai sect, its idiosyncratic image depicted in the Kongokai (diamond realm) Mandala. Depicted with two lesser bodhisattvas (called "kyoji"). The statue dates back to the Kamakura period, and is a designated Municipal Cultural Asset.

屋根裏にあった棟札（むなふだ）に、1695（元禄8）年、1000人の寄進者によって地形と山門を普請したと記されている深大寺。参道より一段高い敷地に立つ茅葺きの山門には、「浮岳山」の山号額。慶応元年（1865）の火災を免れ山内で最古の建物（市指定有形文化財）だ。

A sign posted in the attic states that the temple grounds and gate were constructed in 1695 due to the efforts of 1,000 patrons. On the thatched temple gate set on an elevated plot is a sign reading "Fugakusan" a special mountain name, or "*sango*" given to the temple. This is the oldest structure on the temple grounds, having survived the fire of 1865.

僧形の古像として日本最大の厄除元三大師を安置する元三大師堂（がんざんだいしどう）。慈恵大師良源（じえいだいしりょうげん）（919-85）は比叡山中興の祖。平安の昔に疫病が流行すると並外れた霊力で鬼の姿となり、疫病神を退散させた。秘仏の元三大師坐像は約2ｍの巨像。

The Ganzan Daishi Hall is home to the biggest Ganzan Daishi statue in Japan. Jiei Daishi Ryogen (919-85) is famous for exterminating the plague that struck the Heian capital. This cherished Buddhist image, a rare treat for the public to see, is two meters in height and is depicted in a seated position.

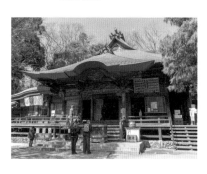

日本全国のお寺や神社にあるおみくじの創始者も、元三大師様。おみくじの元祖・慈恵大師良源の日本屈指の寺院ゆえ試してみるのも有意義。深大寺のおみくじは古来のままなので、凶が多い辛口で有名。凶は吉に好転する力を秘める、と捉える。

Ganzan Daishi is also the progenitor of *omikuji*, written fortunes that can be found at temples and shrines throughout Japan today. As the temple that enshrines the father of *omikuji*, Jindaiji is a perfect place to check your fortune. The temple's *omikuji* are made as they were in the distant past, so there are more "*kyo*" (misfortune) than you will find at many other temples. It is believed, however, that misfortune can be advantageous, as it has the potential to turn into good fortune.

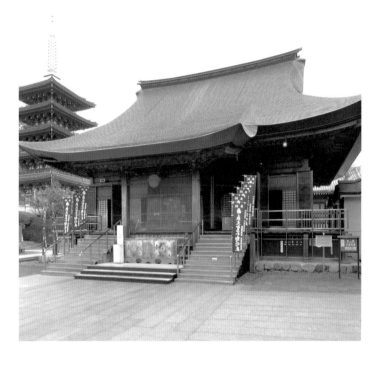

❷ 高幡山明王院金剛寺（日野）

東京都の西部、多摩丘陵麓の一角に、高幡不動尊の名で親しまれる真言密教の寺がある。古来、交通の要衝だった多摩丘陵の尾根筋には、多くの人が行きかった多摩の横山という道が通っており、日本最古の和歌集『万葉集』には、ここを舞台に、西国へ向かった防人との別れを詠んだ歌が収められている。高幡不動尊の創建は平安時代前期、清和天皇の勅願により、天台宗の高僧慈覚大師円仁が堂宇を建て、不動明王像を安置したと伝えられる。以後、武士の信仰を集めて関東屈指の霊場へと発展した。ご本尊は、日本でも最大級の大きさをほこる、平安時代後期の丈六不動明王像(p.18)。現在、脇侍の矜羯羅童子、制多迦童子とともに、奥殿(p.17)で参拝できる。このほか、関東でも希少な古建造物である南北朝時代再建の不動堂（重要文化財p.16）や室町時代建立の仁王門（重要文化財p.20）のほか、約2万点もの寺宝を有する。

⊙ 奥殿・大日堂 9:00〜16:00,護摩修行 8:00〜15:00 の1日5回（詳細HP参照） 料 奥殿寺宝展 300円、大日堂鳴り龍 200円 電 042-591-0032 休 無休。奥殿・大日堂のみ月曜 住 日野市高幡 733 ア 京王線・モノレール高幡不動駅徒歩 5分 ウ takahatafudoson.or.jp

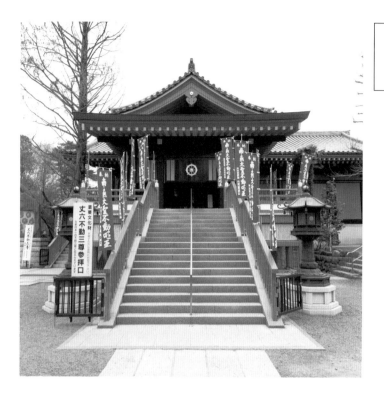

❷ TAKAHATA-FUDOSON KONGOJI (Hino)

Located at the foot of Tama Hill in western Tokyo, Kongoji is better known as Takahata Fudoson. The area was once an important point of meeting along a well-traveled road called *tama no yokoyama*. This road is the setting of a number of poems on parting, in Japan's oldest poetry anthology *Man'yoshu*. The temple began in the early Heian period when Emperor Seiwa ordered Jikaku Daishi Ennin to construct the temple and enshrine Fudo Myo-o there. In later years the temple became a sacred site of *bushido* culture. The great Joroku Fudo Myo-o statue (p.18, late Heian period) enshrined here is the largest in Japan and can be seen in the *okuden* (p.17). There are thousands of other temple treasures to be seen, including the Fudo-do Hall and Nio-mon Gate (p.16 and 20, Important Cultural Properties).

Ⓗ 9:00~16:00, Goma Ritual 5 times/day 8:00~15:00 (see website for more details) Ⓕ Okuden Exhibition Room ¥300, Dainichi Hall ¥200 Ⓣ 042-591-0032 Ⓒ Open Year-round except Okuden/Dainichido, closed Mondays Ⓐd 733 Takahata, Hino City Ⓐc 5-min walk from Takahatafudo Station (Keio Line / Monorail) Ⓤ takahatafudoson.or.jp

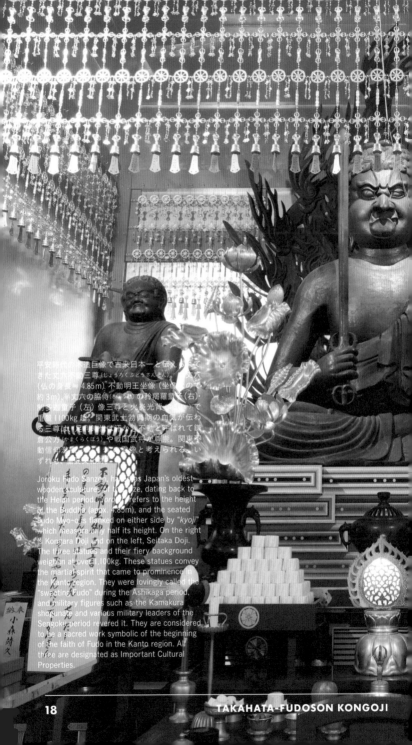

平安時代の□□巨像で古来日本一と伝えられて
きた丈六不動三尊(じょうろくふどうさんぞん)。□丈六
(仏の座長≒4.85m)不動明王坐像(坐像なので
約3m),半丈六の脇侍(きょうじ)の矜羯羅童子(右)・
制多迦童子(左)像三尊と火炎光背□□□で
重量1100kg超。関東武士勃興期の血気が伝わ
る三尊□□□□□□□□□不動と呼ばれて鎌
倉公方(かまくらくぼう)や戦国武将が崇拝。関東□
動信仰□□□□□像と考えられる。い
ずれ□□□□□□□□□。

Joroku Fudo Sanzon, ha□□as Japan's oldest
wooden sculptures of □□□ size, dating back to
the Heian period. "Joro□□ refers to the height
of the Buddha (appx. 4.85m), and the seated
Fudo Myo-o is flanked on either side by "kyoji"
which measure only half its height. On the right
is Kongara Doji and on the left, Seitaka Doji.
The three statues and their fiery background
weigh in at over 1,100kg. These statues convey
the martial spirit that came to prominence in
the Kanto region. They were lovingly called the
"sweating Fudo" during the Ashikaga period,
and military figures such as the Kamakura
shogunate and various military leaders of the
Sengoku period revered it. They are considered
to be a sacred work symbolic of the beginning
of the faith of Fudo in the Kanto region. All
three are designated as Important Cultural
Properties.

重要文化財
木造 不動明王像及び両童子像
（十二世紀・二百年前後）

不動明王像光背銘入品

仁王門。当初、楼門として室町時代に建立されるも途中で変更され、往生の主要部分を覆うように切妻の屋根がかけられていた。1959（昭和34）年の解体修理にて楼門の姿に復原された。楼上の扁額「高幡山」は洛東智積院運敞（ちしゃくいんうんしょう）僧正の筆。

Nio-mon Gate. When constructed, it was to be a two-storied *romon*, but the design was changed mid-construction so that it featured a gabled rooftop above the central section of the gate. The structure was dismantled for repairs in 1959, at which time the original design was restored. The sign hanging in the upper level reads "Takahata-yama" and was written by High Priest Rakuto Chishakuin Unsho.

仁王門をくぐると左手にある水舎（みずや）で手と口を清めて。古来、関東三大不動の一つである真言宗智山派別格本山、高幡山明王院金剛寺は護摩修行が毎日行われているが、火を以て苦の根元、煩悩を焼くことと同様に、水舎には水を以て身を清めることか「洗心」と墨書した布が風に涼やかに揺れていた。

Go through the Niomon gate to find the *mizuya*, or ritual water basin at which visitors wash their hands and mouths. Kongoji, home to one of the three great Fudo statues in Kanto, performs the traditional Goma Ritual every day. Just as this ritual involves the use of fire to burn away *bonno*, the root of human suffering, the *mizuya* is a ritual location where we use water to purify the body.

水舎の水盤にも洗心の文字が刻まれている。柄杓にとる流水の注ぎ口は蓮の形。仏教において蓮は、泥沼に生えて養分を蓄え、泥に染まらぬ清い花を開かせ、同時にもう次の種を持っているという理想を体現した姿。人も種を持ち花開くとなぞらえている。

The same characters found on the hanging cloth sign ("cleanse" and "heart") are engraved into the basin, and the spout is in the form of a lotus. As a plant which grows in marshlands yet is filled with nutrients and produces beautiful flowers, it symbolizes purity. What's more, its flowers hold the seeds to grow the next generation, just as we humans hold seeds which will produce glorious flowers in the future.

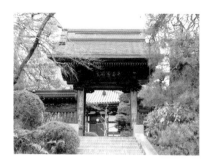

山門。ここを上ると総本堂の大日堂（だいにちどう）がある。1779（安永8）年の大火で焼失した旧堂を改修し、本瓦葺・内陣総漆仕上で材は尾州檜。有名な鳴り龍天井は、外陣天井に裸龍が描かれ、龍の下で手を打つと音が響いて願い事が叶う鳴り（成り）龍と親しまれている。

Past the *sanmon* is Dainichi Hall which burned down in 1779 but was reconstructed. It is made from Japanese cypress called "*bishu-hinoki*," and features a tiled roof and lacquered interior. The famous "dragon-cry ceiling" features the image of a dragon, and it is said that if you clap your hands, the echoes produced will fulfil your wishes, like the great roar of a dragon.

おみくじが結びつけられているこの後ろは、旗かけの松。源頼義（みなもとのよりよし）が、前九年の役（ぜんくねんのえき）（1051-62年）で奥州へ赴く途中、立ち寄って戦勝祈願し、軍旗を立てかけたと伝わる。私より公、母集団全体を守る義に篤い関東の武士の力を得て源氏の基盤がつくられていき、鎌倉に幕府が開かれる、そんな歴史の通り道ともいえる場所。松は2代目。

Behind this *omikuji* display is a pine on which Minamoto no Yoriyoshi supposedly hung his battle flag when he stopped here on his way to Oshu Province during the Former Nine Years' War (1051-62). It's a historical location that helped foster Kanto's warrior ethos of country over self, leading finally to the beginning of the Kamakura shogunate. The current pine is the second planted here.

不動堂は背景に高さ約40mの美しい平安初期様式の五重塔も間近に望める場所。その階段で参拝客の誰もが撫でずにはいられないのが、おびんずるさま。お釈迦様の弟子の一人で、神通力を使いすぎて呵責を受け、衆生（しゅじょう）を救い続けている仏様。疫病の功徳ありと撫でられて漆が剥げている。

Behind Fudo Hall is a beautiful 5-storied pagoda in the early Heian style. A statue of Obinzuru-sama is placed along the stairway, its lacquer fading from the touch of visitors. Obinzuru-sama was a disciple of Buddha who used his spiritual powers to save others despite the suffering he underwent for overusing these powers. He has the power to cure pestilence, which is why visitors always touch him as they pass.

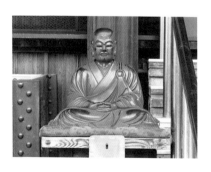

TAKAHATA-FUDOSON KONGOJI

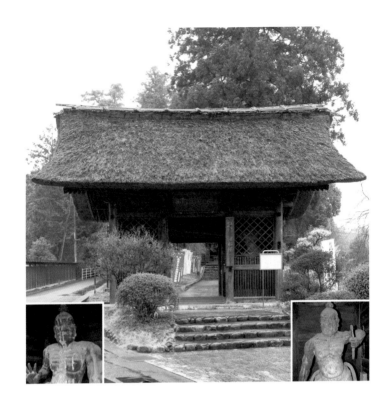

❸ 塩船観音寺（青梅）

2020（令和2）年3月に、ご本尊、十一面千手観音立像（p.23左）とその眷属、二十八部衆立像（p.23右下）が、重要文化財に指定された塩船観音寺。丘の頂にある平和観音像から境内を見下ろすと、寺名の由来も一目瞭然の船底形をしているのがわかる。春にはその斜面を取り囲むツツジが一面に開花し、多くの参拝客が夢幻の光景を楽しむ。寺の草創は七世紀とも八世紀とも言われているが、詳細は不明である。十一面千手観音立像は秘仏だが、年に数回、拝観する機会がある。鎌倉時代の1264年に仏師、快勢らがつくったことがわかっている、貴重なものだ。二十八部衆立像は、ご本尊の厨子の左右両脇に14体ずつ安置されており、こちらはいつでも拝観できる。仏師、定快作で、1268年から21年間もの時間をかけてつくられた入魂の作である。これらのほか、寺で最古の仏像、平安後期と推定される薬師如来（p.23右上、市有形文化財）も見応えがある。

㊙8:00〜17:00　㊚つつじ祭（4月中旬〜5月上旬）のみ入山料300円　㊝0428-22-6677　㊡無休　㊟青梅市塩船194　㋐JR河辺駅よりバス塩船観音入口徒歩10分（4月末〜5月上旬同区間直通臨時バス運行）　㋒shiofunekannonji.or.jp

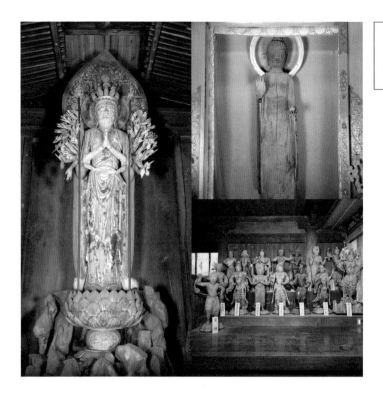

❸ SHIOFUNE KANNONJI (Oume)

The temple's *honzon*, the "11-faced, thousand-handed Kannon" statue (p.23, left) and accompanying Buddhist sculptures, the "group of 28" (p.23, lower right) were designated National Important Cultural Properties in 2020. Looking down upon the temple grounds from the Heiwa Kannon, one can see from the boat-like shape where the temple gets its name ("*fune*" means "boat" in Japanese). The gorgeous sloping hills, vibrant red with Rhododendrons in spring, are a place where people can come and lose themselves in the sublime scenery. It is unknown when the temple was founded, but the *honzon* was created by the Buddhist sculptor Kaisei in 1264, and it can be seen only on special occasions throughout the year. The 28 attendants, 14 on each side, can be seen all year round. They were made by the sculptor Jokai over a period of 21 years, starting in 1268. The temple also houses a *yakushi nyorai* (p.23, upper right, Municipal Designated Tangible Cultural Property) from the late Heian period.

Ⓗ 8:00~17:00　Ⓕ During Rhododendron Festival (mid-April~early May) ¥300　Ⓣ 0428-22-6677
Ⓒ Open Year-round　Ⓐd 194 Shiofune, Oume City　Ⓐc JR Kabe Station (Oume Line)-Shiofune Kannon entrance (bus) then 10-min walk　Ⓤ shiofunekannonji.or.jp

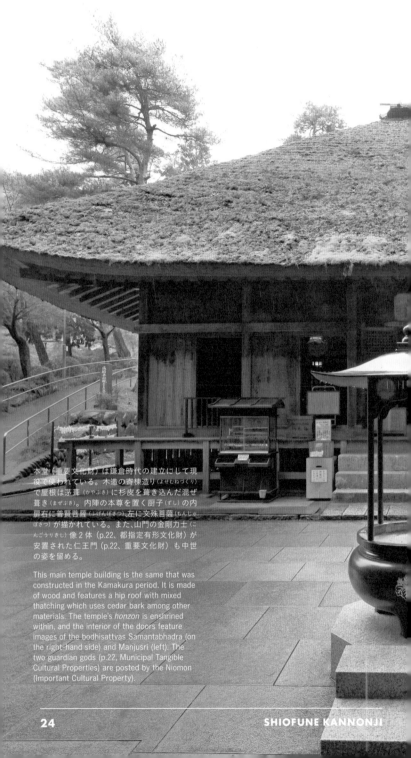

本堂（重要文化財）は鎌倉時代の建立にして現役で使われている。木造の寄棟造り（よせむねづくり）で屋根は茅葺（かやぶき）に杉皮を葺き込んだ混ぜ葺き（まぜぶき）。内陣の本尊を置く厨子（ずし）の内扉右に普賢菩薩（ふげんぼさつ）、左に文殊菩薩（もんじゅぼさつ）が描かれている。また、山門の金剛力士（にんごうりきし）像 2 体（p.22、都指定有形文化財）が安置された仁王門（p.22、重要文化財）も中世の姿を留める。

This main temple building is the same that was constructed in the Kamakura period. It is made of wood and features a hip roof with mixed thatching which uses cedar bark among other materials. The temple's *honzon* is enshrined within, and the interior of the doors feature images of the bodhisattvas Samantabhadra (on the right-hand side) and Manjusri (left). The two guardian gods (p.22, Municipal Tangible Cultural Properties) are posted by the Niomon (Important Cultural Property).

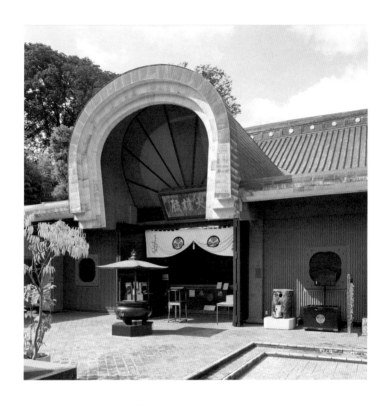

❹ 五百羅漢寺（目黒）

日本の仏教彫刻は、仏教が伝来した飛鳥時代から連綿と隆盛するが、江戸時代に活躍した仏師、松雲元慶のつくった彫刻も、それに比肩する見事さ。ここ五百羅漢寺で見ることができる。京都生まれの松雲が、九州の耶馬渓で羅漢像を礼拝し、造像を思い立って、江戸で500体を一心に彫ったのが、こちらの東京都指定文化財の五百羅漢像である。これらは、江戸時代に、明清時代の中国から伝わった黄檗宗の仏像様式の代表作例。寄進を受けずに彫像することはご法度だった当時、噂を聞いた将軍綱吉が特別に寄進、その後十数年間で完成したという。「震災や空襲に遭っても人々が運び出して守り抜いたお陰で、江戸文化の華である木造の305体が一堂に残り、300年経っても目にできる、東京でも稀な場所です」とお寺の堀研心さん。信仰の証の存在感と多彩な表情は圧巻。羅漢さんには若貌、壮貌、老貌の３つのお顔があり、親しみが湧いた像は、今の自分の姿と同じだともいわれている。

㉑ 9:00 〜 17:00（拝観受付〜16:30）㉝ 500円 ㉰ 03-3792-6751 ㉗無休 ㉕目黒区下目黒 3-20-11 ㋐JR 目黒駅徒歩 12分・東急線不動前駅徒歩 8分・東急バス不動尊参道徒歩 2分 ㋒ rakan.or.jp

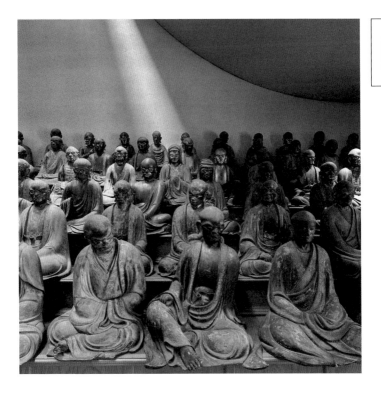

❹ GOHYAKU RAKANJI (Meguro)

Buddhist sculpture has flourished since the Asuka period, and Edo-era artist Shoun Genkei's work deserves a place among the greats. His 500 Rakan statues are here at Gohyaku Rakanji. Born in Kyoto, Shoun sculpted the Rakan statues in Edo after visiting Rakanji in Yabakei, Kyushu. They are now a municipal Cultural Property. Shoun was able to make the statues because of a donation from Shogun Tsunayoshi, and they took over a decade to complete. "Thanks to the many people who helped move the statues during natural disasters, air raids, etc., 305 of the original statues still remain under one roof as a testament to Edo culture. It's a rare experience to see something that has survived over 300 years in Tokyo," says Rakanji's Kenshin Hori. These works are true masterpieces which give form and reality to the faith of Gohyaku Rakanji. There are three faces of Rakan—the young, the prime, and the old—and whichever resonates with you personally is said to represent your current state.

(H) 9:00~17:00 (No entrance after 16:30) (F) ¥500 (T) 03-3792-6751 (C) Open Year-round (Ad) 3-20-11 Shimo-meguro, Meguro-ku (Ac) 12-min walk from JR Meguro Station, 8-min walk from Fudo-mae Station (Tokyu Line), 2-min walk from Fudo-son Sando bus stop (U) rakan.or.jp

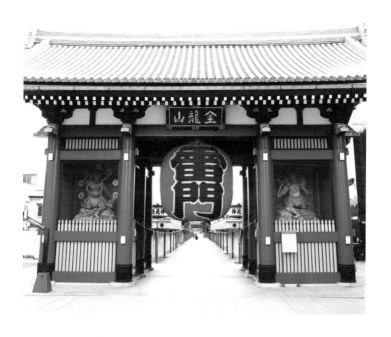

❺ 浅草寺（浅草）

浅草寺といえば、雷門の大提灯、参道両脇に並ぶ仲見世、青空に映える本堂……、誰もが写真に収めたくなる、東京の観光名所だ。寺の創建は628（推古天皇36）年、今から1400年前の飛鳥時代7世紀にさかのぼる。現在の墨田川で漁をしていた人の網の中から聖観世音菩薩像があらわれ、やがてお堂を建ててこれをお祀りしたのが寺の始まりであるという。観音菩薩は人々の苦しみを救う慈悲の仏で、なかでも聖観音菩薩はあらゆる観音菩薩の基本的な姿。本尊聖観音菩薩像は絶対の秘仏で、誰の目に触れることもなく、本堂内陣の御宮殿内奥深くに安置されている。御前立という本尊のお身代わりの像のみ、年に1度、12月13日14時に拝むことができる。また、浅草寺の寺宝として有名な、国宝の『法華経』は観音菩薩に深く関わりのあるお経。王朝文化華やかな平安時代後期の作で、金銀箔できらびやかに装飾されている（東京国立博物館に寄託中）。

⏰ 6:00〜17:00（10〜3月は6:30〜）　☎ 03-3842-0181（日・祝を除く9:30〜16:00）　休 無休　住 台東区浅草2-3-1　ア 東武線・地下鉄・都営線・つくばエクスプレス浅草駅徒歩5分　ウ senso-ji.jp

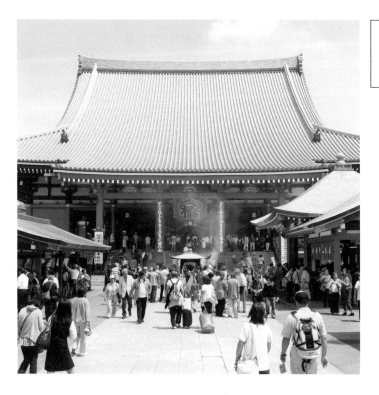

❺ SENSO-JI (Asakusa)

The great lantern of Kaminarimon, the shops along the sando, and the bright red temple hall against the sky are truly a sight to behold, and Sensoji is undoubtedly one of the most well-known tourist spots in all of Tokyo. Its history goes back over 1400 years to the time of Empress Suiko in 628. As legend has it, a fisherman on what is now the Sumida River found the image of Sho Kannon in his nets and went on to build the temple to enshrine it. Sho Kannon is the Buddhist goddess of mercy on which other versions of Kannon are based. The *honzon* is kept away from the public, but a replacement statue called "*omaedachi*" can be seen once a year on December 13th at 2pm. The temple's 11th-century copy of The Lotus Sutra, a national treasure, has a strong connection to Sho Kannon. It is a highly decorative volume with gold highlights popular during the Heian period. It can be seen at the Tokyo National Museum in Ueno.

(H) 6:00~17:00 (Oct-Mar 6:30~) (T) 03-3842-0181 (C) Open Year-round (Ad) 2-3-1 Asakusa, Taito-ku
(Ac) 5-min walk from Asakusa Station (Tobu Line / Metro / Toei Line / Tsukuba Express) (U) senso-ji.jp

SENSO-JI **29**

神社仏閣豆知識：神社編

神社とは？

高層ビル群から山の頂、家の庭など至るところに神社があるが、神社本庁の公式サイトによれば、神社とはみんなが幸せや家族の安全を願い、地域や国がますます豊かになるように祈りを捧げるところで、ここでお祭りが行われている、ということ。神道では海、山、火、水、木、風などの自然の神様、また昔の天皇、徳川家康公、菅原道真公などの歴史上の神様、ご先祖様、氏神様と、八百万の神がいらっしゃる。

社、宮、権現、稲荷、明神の違いは？

古来、「神宮」は伊勢の神宮を指し、「○○神宮」は皇祖や天皇をお祀りする特定の神社。「神社」は広く用いられる社号。「宮」は天皇や皇族を祀る神社や古い呼称。「大社」は出雲大社を示す。社号でなく神様の名前に付す「大神」「大明神」「権現」もあり、各地に守護神の神明様、氏神様、お稲荷様、八幡様、天神様、住吉様、お諏訪様の御神格も。号は異なっても神社への篤い信仰は変わらない。

正しい参拝の仕方は？

その神社に教わるのが正解。例えば愛宕神社では、鳥居は「天の岩戸」神話で常世の長鳴き鳥の鶏を止まらせた木を模した世俗と神域との結界。鶏は夜明けを告げ、鳥居をくぐることによって新しい日が始まるという意味があるので、心を静め、ちょっと一礼してくぐるとある。手水では右手で柄杓に水を汲み左手を清め、持ち替えて右手を、再び右手で持ち左手に水を受けて口をすすぎ、左手を清め、柄を清めて元に戻す。社殿で神様の前に出たら鈴を鳴らし、お賽銭を入れてから2回深いおじぎをして2回手を打ち、もう1回深いおじぎ。この二礼二拍手一拝が神様に祈る作法。

お守り・おみくじに決まりはある？

神様のお力をいただくお守りは願いが叶うまで身につけてよく、たくさんあっても八百万神が協力し合い助けるのでOK。おみくじは今後の生活指針。結ぶ習わしもあるが持ち帰ってもいい。

※神社本庁の公式サイト（jinjahoncho.or.jp/）を参考にしています。

TRIVIA ON SHINTO SHRINES

WHAT ARE SHRINES?

The Association of Shinto Shrines defines a shrine as a place where people pray for family safety, happiness, etc., and where festivals are held and we pray for prosperity. According to Shinto, there are natural gods (of mountain, sea, etc.) and historical gods (emperors and historical figures). There are also ancestral gods, patron gods, and the "myriad gods," all of which reside in shrines throughout Japan.

DIFFERENCES BETWEEN SHRINES?

Originally, "*jingu*" refers to Ise Shrine. It now refers to shrines dedicated to emperors and imperial ancestors. "*Jinja*" is the general term for shrines. "*Miya*" refers to shrines dedicated to emperors and is also a general term. "*Taisha*" refers to Izumo Taisha. Certain suffixes apply to the names of *kami*, such as "*daijin*," "*daimyojin*" and "*gongen*." The guardian deities of Japan are another subset of gods, including the fox deity Oinari and god of war Hachiman. Though there are different kinds, the faith of each shrine's priests and patrons is unwavering.

THE PROPER WAY OF PAYING HOMAGE

The way you pay homage depends on the shrine. At Atago Shrine, the *torii* is said to derive from a myth in which the gods tricked Amaterasu into coming out of her cave by having a rooster crow. The *torii* represents the tree where the mythical bird perched, a threshold between world and sacred shrine precincts. Passing through the gate represents the dawn at the rooster's crow. At the "*temizu*", first take the ladle with your right hand and pour water over your left. Change hands and wash your right hand. Next, return the ladle to your right hand, cup the water in the left and rinse your mouth. Lastly, pour water over the left hand once more before returning the ladle to its original position. When appearing before the shrine, ring the bell before making your offering. Bow deeply twice, clap twice, and bow once more. This method is the standard way to pray before a Shinto god.

OMAMORI AND *OMIKUJI*

Omamori are lucky charms imbued with the power of the gods. You can have as many as you like, as the "myriad gods" will work together to help you. *Omikuji* tell your fortune. You can tie them and leave them at the shrine or take them home with you.

Some information taken from the Association of Shinto Shrines website (jinjahoncho.or.jp/)

PART_2

建築、都市論という視点で、見る

ARCHITECTURAL AND CITY
DEVELOPMENT PERSPECTIVES

徳川の治世に地形を生かし計画された江戸・東京。
古を尊崇する写しの美学が生んだ信仰空間を歩く

建築家であり、大学で講義や研究も行う福島加津也さん。「東京の神社仏閣は、東京が近世に徳川幕府によって自然を生かして人工的に計画された新しい都市であることと、明治以降に政治や経済の流れに翻弄されてきたこと、この2つが、京都・奈良の神社仏閣にはない大きな特徴です。それによって独特の佇まいや景観を見せているんですね」。例えば、上野の山は京の都を守護する比叡山に見立てて写し取られたという。琵琶湖の竹生島まで模した不忍池を見下ろす場所にあった寛永寺（延暦寺の見立て）は、桜並木のアプローチが夢幻を誘う景観を演出するなど極楽浄土のテーマパークのような信仰空間だったそう。融通無碍に呼応しながら人々の心に根づいてきた、そんな神社仏閣を訪れてみたい。

Edo, a City Designed During the Reign of Tokugawa
An Aesthetic With Reverence for the Past

Architect, university lecturer and researcher Katsuya Fukushima gives us his perspective. "Shrines and temples in Tokyo are distinct from those in Kyoto and Nara in that they are part of a city that was designed by the Tokugawa Shogunate (1600-1868) to emphasize the natural landscape, and that this same city was greatly affected by the incredible governmental and economic developments that have continued since the Meiji period (1868-1912). These two factors give the temples and shrines in the city a unique impression." They say the hill known as Ueno Mountain was meant to resemble Mt. Hie that protects the old capital Kyoto, and Kanei Temple is based on Enryaku Temple. The approach to the temple, lined with cherry trees gives visitors the sense that they have entered the Pure Land of Buddhist legend. This and many more enchanting shrines and temples await in Tokyo.

ARTRIP ADVISER

福島加津也さん
Katsuya Fukushima

建築家、東京都市大学建築学科教授。福島加津也＋冨永祥子建築設計事務所を主宰。日本の伝統を現代のデザインに取り入れたスタイルが特徴。作品数は少ないが国内外の賞を多数受賞している。建築設計と並行して木造建築や集落調査研究も行う。

Architect and Professor of Architecture, Tokyo City University. Chairman, FT Architects. Though Mr. Fukushima's works are few, he has won many domestic and international awards. He also conducts research in wooden architecture and small community surveys

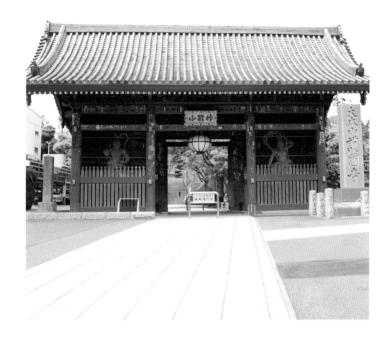

❻ 護国寺（大塚）

お釈迦様の教えを書き取った膨大なお経のなかでも、大乗仏教初期に成った『法華経（ほけきょう）』は、聖徳太子の時代に仏教とともに日本へ伝来し、のちに災害や疫病が多発すると鎮護国家を祈る護国の経典としても読まれるようになった。『法華経』の一品（いっぽん）（章）、観音経は、仏の悟りを求めて修行中の人である菩薩の一尊、観音菩薩が33通りの姿を自在に現して諸難救済することを説いたお経。江戸三十三観音札所（えどさんじゅうさんかんのんふだしょ）でもある護国寺は、そんな観音様を間近に念じて慈悲に触れられる、安らぎの場といえる。創建は1681（天和（てんな）元）年。5代将軍徳川綱吉公が生母、桂昌院の発願（けいしょういんほつがん）から上野国（群馬県）（こうずけのくに）大聖護国寺（だいしょうごこくじ）の亮賢僧正（りょうけんそうじょう）を招いて開山し、幕府所属の高田薬園の地に堂宇（どうう）を建立。さらに幕命で観音堂を半年あまりで新営し、これが今の本堂で、震災・戦災と2度の大災害を逃れて現存する（重要文化財）。桂昌院念持仏（けいしょういんねんじぶつ）の天然琥珀如意輪観世音菩薩像（にょいりんかんぜのんぼさつ）はご秘仏。文化財と自然も楽しめる大寺院だ。

⏰ 9:00〜16:00（12:00〜13:00 閉堂。行事等により拝観不可もあり）　☎ 03-3941-0764　🈳 無休
🏠 文京区大塚5-40-1　🅐 地下鉄護国寺駅徒歩1分　🆄 gokokuji.or.jp

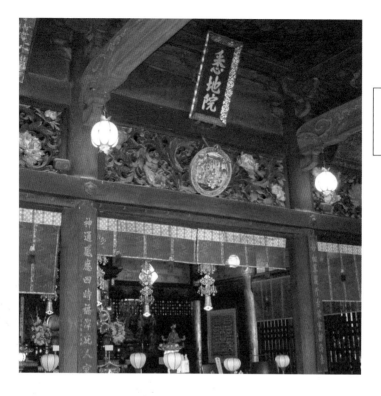

❻ GOKOKUJI (Otsuka)

Lotus Sutra is one of the most important early sutras of Mahayana Buddhism. It was recited to protect the country after Prince Shotoku brought Buddhism to Japan and the country suffered many natural disasters and plagues. A section of *Lotus Sutra* called "*Kannon-kyo*," tells of the bodhisattva Kannon, who appeared in 33 different forms to save all beings. Gokokuji Temple is one of the 33 temples of Edo dedicated to Kannon, a peaceful place imbued with sacred compassion. The temple was built in 1681 at the request of Kei Sho-in, Tokugawa Tsunayoshi's (the fifth shogun) mother. It was constructed on a site belonging to the shogun and used for the cultivation of medicinal herbs. Within half a year Kannon Hall was built. It has survived earthquakes, war, and two other natural disasters, and is now the temple's main hall. The amber Kannon statue (*Nyoirin Kanzeon Bosatsu*) that belonged to Kei Sho-in is in the temple's possession but kept from public view. Visitors can enjoy both culture and nature at this grand temple.

Ⓗ 9:00~16:00 (closed 12:00-13:00. Temple may be closed to the public due to annual events and rites) Ⓣ 03-3941-0764 Ⓒ Open Year-round Ⓐd 5-40-1 Otsuka, Bunkyo-ku Ⓐc 1-min walk from Gokokuji Metro Station Ⓤ gokokuji.or.jp

GOKOKUJI

一棟（ひとむね）の桁行（けたゆき）7間（間口。1間≒畳の長辺182cm）、梁間（はりま）（桁と直交する短辺）7間、より格式の高い一重入母屋造り（いりもやづくり）で向拝（こうはい）（並ぶ参拝者の雨除けに階段まで屋根をかける庇を延長した軒の深さ）3間、瓦棒銅板葺（かわらぼうどうはんぶき）の堂々たる本堂は、国指定重要文化財。

A highly formal building made in a square shape, this hall is approximately 13 meters wide and 13 meters long, with a gabled roof of copper tile and overhanging eves that measure approximately 5 meters. This magnificent building is a designated National Important Cultural Property.

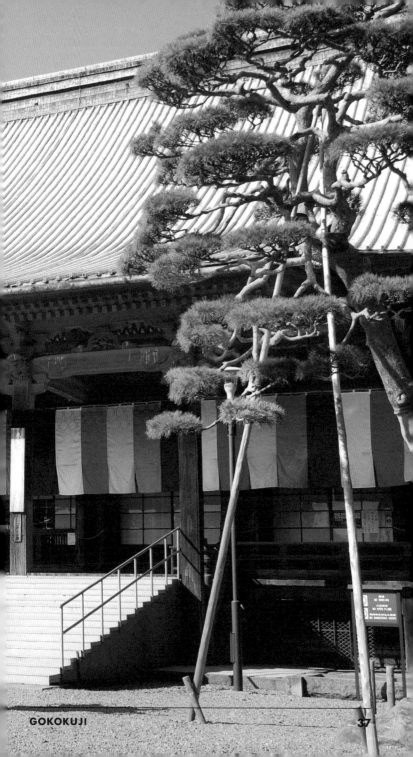

1697（元禄10）年落成の姿を残す観音堂（本堂、重要文化財）。多宝塔（たほうとう）左手の月光殿（げっこうでん）は、近江三井寺（みいでら）より移築し桃山期の書院様式を今に伝える（重要文化財。写真右上）。薬師堂、大師（だいし）堂、忠霊（ちゅうれい）堂、創建時のものと伝わる仁王門（区指定文化財）、惣門（そうもん）、不老門（中門（なかもん））が保存または再建されている。

Kannon-do (the main hall, Important Cultural Property), standing since 1697. Gekko-den (photo, upper right, Important Cultural Property), to the left of Taho-to Tower, was moved here from Miidera Temple in Omi, and is a wonderful example of a typical drawing room of the Momoyama Period. Also of note are Yakushido, Daishido, Chureido, Niomon (Designated Cultural Property), Somon, and Furomon or Nakamon (these last three "gates" have survived since the temple's founding), all of which have been preserved or reconstructed.

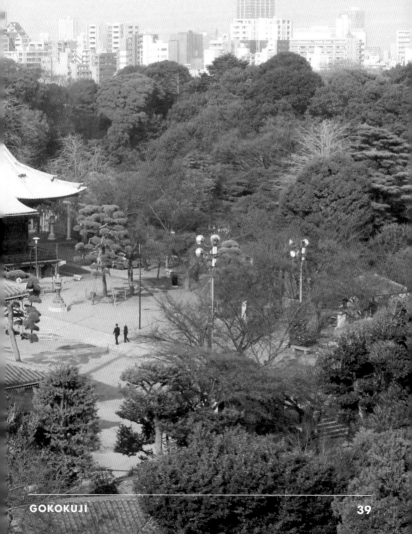

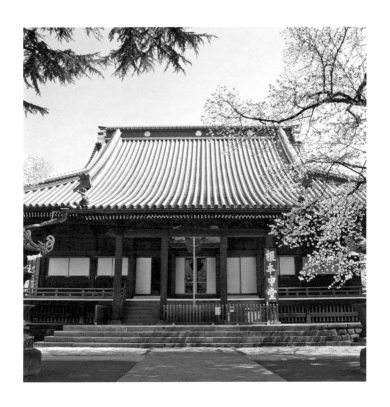

❼ 寛永寺（上野）

江戸期屈指の名所、上野を描く浮世絵は 700 〜 800 点にも上るといわれる。その隆盛の源泉こそ寛永寺で、さらにはご開山、108歳の長寿を全うして遷化した慈眼大師・天海大僧正ともいえる。家康・秀忠・家光と徳川三代の保護を受け、9 世紀に最澄上人が開いた天台宗の一大拠点を江戸に築くべく計画を進め、平安京（京都）と比叡山延暦寺をトレースするかのごとく、江戸城鬼門（東北）の上野の台地に寺地を得て、山号は東叡山（東の比叡山）、寺号も延暦寺同様、勅許を得て元号を採って建立。法華堂や中堂（本堂）などはもちろん、不忍池辯天堂は比叡山麓の琵琶湖竹生島を写し、清水堂（重要文化財）の舞台造りは京の清水寺から御本尊を、祇園堂は八坂の祇園様を勧請。吉野桜も移植した。1868（慶応 4）年、官軍の総攻撃を受けて伽藍はほぼ灰燼に帰し、現在一帯は上野公園に。寛永寺はなおも 19 の子院があり、御秘仏（薬師瑠璃光如来像、重要文化財）の威光や文化財が参詣客を惹きつけている。

㉠9:00 〜 17:00　㉫03-3821-4440　㉖無休　㉕台東区上野桜木 1-14-11　㋐JR 上野駅・鶯谷駅徒歩8分　㋒kaneiji.jp

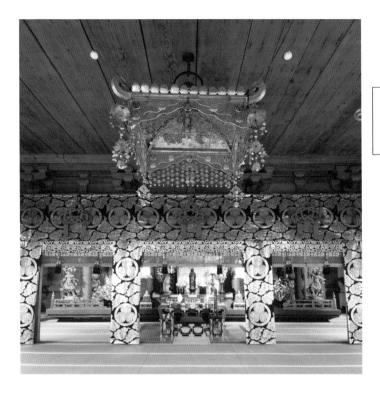

❼ KANEIJI (Ueno)

It is said as many as 800 *ukiyo-e* that depict famous locales of Edo show the Ueno area. Kaneiji Temple is undoubtedly one of the biggest reasons for Ueno's popularity, a temple said to be founded by the High Priest Tenkai, who lived to the age of 108. The temple was patronized by three generations of Tokugawa shoguns, and was constructed as the center of Tendai Buddhism, a sect founded by Priest Saicho in the 9th century. The temple mirrors Enryaku Temple on Mt. Hiei, situated in the unlucky northeastern quarter relative to the castle and given the name "Toeizan," or "Eastern Hiei Mountain." Like Enryaku Temple, Kanei Temple lends its name to the era name by official decree. The Hokkedo and Chudo Halls mirror Enryaku, as well as Shinobazu Pond and Bentendo Temple, which are modeled after Lake Biwako and Chikubu Island at the foot of Mt. Hiei. The principle object of worship at Kiyomizu-do was brought from Kyoto's Kiyomizu Temple, and Giondo is modeled after Yasaka Shrine in Kyoto.

(H) 9:00~17:00 (T) 03-3821-4440 (C) Open Year-round (Ad) 1-14-11 Ueno Sakuragi, Taito-ku
(Ac) 8-min walk from JR Ueno Station / Uguisudani Station (U) kaneiji.jp

「東都名所上野東叡山全図」は、江戸後期、一立斎（いちりゅうさい）広重（歌川広重初代）の作品で、満開の桜と物見遊山の市民、根本中堂（こんぽんちゅうどう）を中心に吉祥閣、常行（じょうぎょう）堂・法華堂、清水観音堂など寛永寺の主要伽藍を描いている。旧寛永寺五重塔は現在、都に寄託し上野動物園内に残る。

The "Complete Illustration of Ueno Toeizan" is a work by Ichiryusai Hiroshige (Utagawa Hiroshige I), an *ukiyo-e* artist of the late Edo period. It depicts Edo citizens enjoying themselves among the cherry blossoms. In the center is Konpon Chudo hall, surrounded by many other structures including Kisshokaku, Jogyodo (Hokkedo), and Kiyomizu Kannon-do. The former Kanei Temple Five-storied Pagoda was given to the city and can be seen at Ueno Zoo.

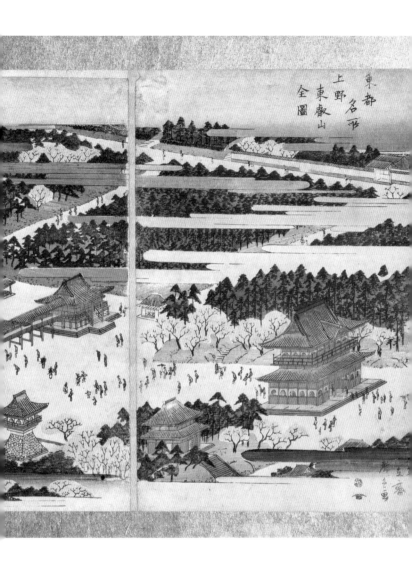

東都名所上野東叡山全圖

広重画

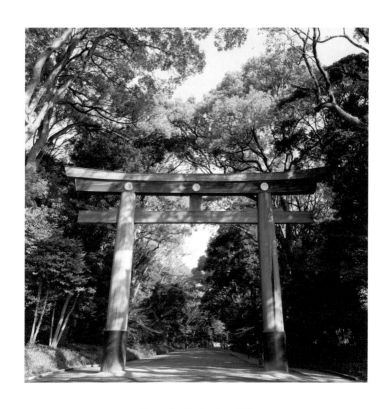

❽ 明治神宮（原宿）

初詣で日本一の参拝者数を誇る明治神宮は、平日の午前中でも多くの人が第一鳥居（写真上）から森林浴を楽しみ本殿へと向かっていく。まるで自然林のような鬱蒼とした森を歩くと、創建時に全国から約10万本の献木、そして延べ11万人におよぶ青年団による勤労奉仕、国民のまごころが結集したことに思いを馳せる。また参道沿いに奉献された日本酒やワインの酒樽を眺めれば、御祭神への篤い崇敬心が伝わってくるだろう。大鳥居こと第二鳥居は明神鳥居として日本一大きな木造で、篤志家と台湾の人々の協力により樹齢1500年を超す台湾檜が運ばれ再建されたもの。正参道からいよいよ神域の要の本殿へ。御祭神は、明治天皇と皇后の昭憲皇太后。明治天皇が1912（明治45）年に崩御されると、御神霊を祀る気運が沸き、1920（大正9）年、明治神宮が創建された。そして2020（令和2）年、鎮座100年を迎える。

時 日の出〜日の入り（毎月変動、HP参照）　電 03-3379-5511　休 無休　住 渋谷区代々木神園町1-1　ア JR原宿駅・地下鉄明治神宮前駅徒歩1分　ウ meijijingu.or.jp

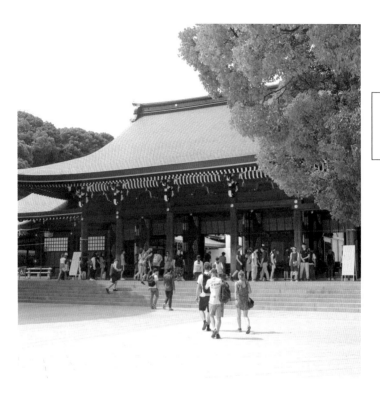

❽ MEIJI JINGU (Harajuku)

Meiji Jingu boasts the most *hatsumode* visitors in Japan. Even on weekday mornings, the shrine is filled with visitors walking from the first *torii* gate through the forested grounds, finally arriving at the *honden* (main shrine). The beautiful forest looks to be the work of nature, but is in fact the product of approximately 100,000 trees that were dedicated to the shrine from around the country at its founding. One can't help but feel the deep reverence and dedication of the people of Japan. The second *torii* gate is the largest wooden Myojin-style *torii* in Japan. This construction was led by a patron Taiwanese, who found trees over 1,500 years old to use in Taiwan. Enshrined in the main hall are the souls of Emperor Meiji and Empress Shoken. After the passing of Emperor Meiji in 1912, a movement began to enshrine him, and in 1920 Meiji Jingu was constructed. In 2020, the shrine will reach its centennial!

Ⓗ Sunrise to sunset (changes monthly, check the shrine's homepage)　Ⓣ 03-3379-5511　Ⓒ Open Year-round　Ⓐ d 1-1 Yoyogi-kamizonocho, Shibuya-ku　Ⓐ c 1-min walk from JR Harajuku Station / Meiji-Jingumae Metro Station　Ⓤ meijijingu.or.jp/en/

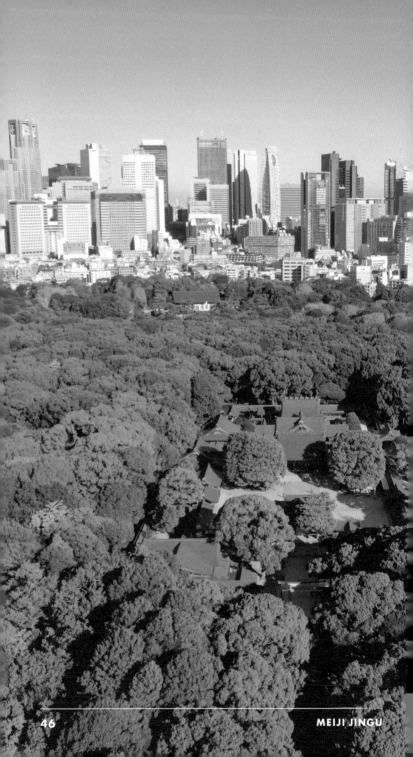

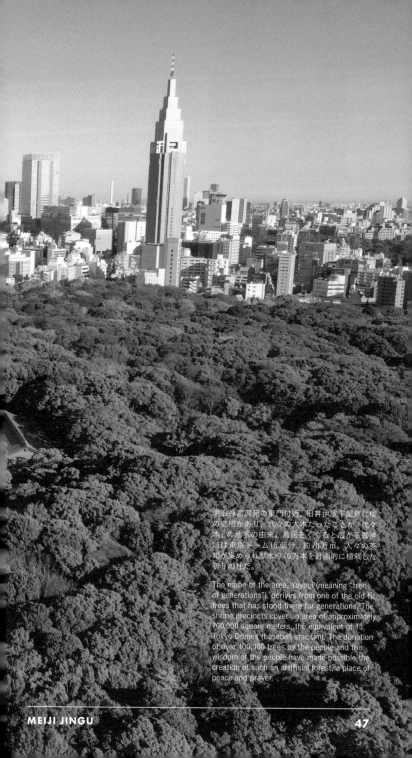

明治神宮御苑の東門付近、旧井伊家下屋敷に楠の老樹があり、代々の大木だったことが「代々木」の地名の由来。鳥居をくぐると広がる御神域は東京ドーム15個分、約70万㎡。人々の英知が集められ献木約10万本を計画的に植栽した祈りの杜だ。

The name of the area, Yoyogi (meaning "tree of generations"), derives from one of the old fir trees that has stood there for generations. The shrine precincts cover an area of approximately 700,000 square meters, the equivalent of 15 Tokyo Domes (baseball stadium). The donation of over 100,000 trees by the people and the wisdom of the people have made possible the creation of such an artificial forest, a place of peace and prayer.

MEIJI JINGU

47

創建時の社殿設計は伊東忠太（いとうちゅうた）、1958（昭和33）年の再建設計は角南隆（すなみたかし）。廻廊の照明は、皇室の正式な菊の御紋、16弁の「十六葉八重表菊（じゅうろくようやえおもてぎく）」と皇室に遠慮し数を減らした12弁の両方をデザイン。

The original shrine was designed by Ito Chuta, while Sunami Takashi oversaw the 1958 reconstruction project. The interior lanterns use both the official imperial seal, the image of a 16-petaled chrysanthemum, and the 12-petaled emblem created out of consideration toward the imperial house.

南神門は1920（大正9）年創建当時の姿を残す。1945（昭和20）年4月13～14日のアメリカ軍機による空襲で社殿はほぼ焼失したなか、この楼門と手前の宿衛舎、廻廊の一部が残った。第三鳥居は国産檜材。

The southern gate still remains since the shrine's 1920 founding. The air raids of April 13-14, 1945 destroyed most of the shrine buildings, but this gate, a small structure called a *shukueisha*, and part of a corridor survived. The third *torii* gate is notably made from domestic *hinoki* cypress.

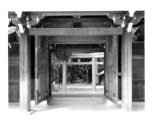

本殿左手でひときわ目立つ、丸く大きなご神木は、1920（大正9）年の創建当時に植栽された2本のクスノキが成長。明治天皇と皇后の昭憲皇太后の仲睦まじかったことにあやかり、縁結び、家内安全を象徴するとして"夫婦楠（めおとくす）"と親しまれている。

Two camphor trees, planted at the time of the shrine's founding, stand next to the main hall. Meant to symbolize the relationship between Emperor Meiji and his wife, the trees represent harmonious marriage and family safety. They are lovingly known as *meoto-kusu* ("husband and wife camphors").

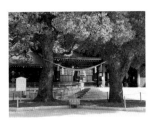

参拝者が授与所で求めた祈願絵馬に思い思いに願いや感謝、誓いの言葉を記し、奉納している。独自のおみくじ「大御心（おおみごころ）」は明治天皇の御製（ぎょせい）または、昭憲皇太后の御歌（みうた）30首から1首を引き当てるもので解説付き。

Worshipers dedicate their *ema* here with words of gratitude and sacred vows. The unique *omikuji* you can draw here are called *omi-gokoro*, and they feature poems written by Emperor Meiji and his wife instead of the usual fortunes. The poems also include helpful explanations.

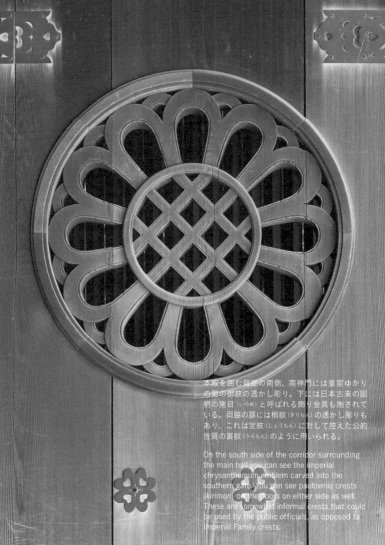

本殿を囲む廻廊の南側、南神門には皇室ゆかりの菊の御紋の透かし彫り。下には日本古来の図柄の猪目（いのめ）と呼ばれる飾り金具も施されている。両脇の扉には桐紋（きりもん）の透かし彫りもあり、これは定紋（じょうもん）に対して控えた公的性質の裏紋（うらもん）のように用いられる。

On the south side of the corridor surrounding the main hall you can see the imperial chrysanthemum emblem carved into the southern gate. You can see paulownia crests (*kirimon*) on the doors on either side as well. These are somewhat informal crests that could be used by the public officials, as opposed to Imperial Family crests.

明治天皇・昭憲皇太后おゆかりの御物から 100 年が見渡せる

100-Year-Old Imperial Treasures of Emperor Meiji and Empress Shoken

明治神宮ミュージアム

南参道を進んですぐ右に現れる入母屋造とガラスの建物が、明治神宮鎮座 100 年祭を迎えるにあたり 2019（令和元）年に開館した明治神宮ミュージアム。明治神宮は 1920（大正 9）年に代々木の地に鎮座し、その翌年に明治天皇・昭憲皇太后両御祭神のご愛用の御物を納めた宝物殿が造営された（現在、重要文化財として境内に保存）。ミュージアムではその収蔵する御宝物の数々が 2 階・宝物展示室で公開され、企画展示室では企画展、また映像展示も楽しめる。

㊞10:00〜16:30（最終入館は閉館 30 分前まで）　㊙1000 円　㊟03-3379-5875　㊡木曜（祝日の場合は開館）、展示替期間　㊠渋谷区代々木神園町 1-1　㊐ JR 原宿駅西口・地下鉄明治神宮前駅徒歩 5 分　㊣ meijijingu.or.jp

THE MEIJI JINGU MUSEUM

The Meiji Jingu Museum was opened in 2019 to coincide with the shrine's centennial the following year. The gable-roofed, glass-walled building can be seen on your right as you walk along the southern road toward the main shrine. The items that once belonged to Emperor Meiji and Empress Shoken were originally placed in the Treasure Museum (Homotsuden) when the shrine was established, and this hall is now an Important Cultural Property. These items can now be seen in the museum's 2nd floor exhibit room. You can also see special exhibits and videos in the special exhibit room.

(H) 10:00~16:30 (No entrance after 16:00)　(F) ¥1,000　(T) 03-3379-5875　(C) Closed Thursdays (open holidays) and when the exhibits are being changed　(Ad) 1-1 Yoyogikamizono-cho, Shibuya-ku　(Ac) 5-min walk from JR Harajuku Station South Exit / Meiji-Jingumae Metro Station　(U) meijijingu.or.jp/en/

ボリュームを低く抑えた延床面積約3,200㎡の2階建ての建築は、どこか新国立競技場や根津美術館とも連続性を感じさせる隈研吾（くまけんご）の設計。3つの展示室と映像ルームとで明治の聖代を語り継ぐ。

This low two-floor, 3,200 square meter building is a work of Kuma Kengo, and naturally shows a certain resemblance to the Japan National Stadium and Nezu Museum. 3 exhibit rooms and the "Image Room" tell the story of Emperor Meiji's reign.

メインロビーはシャープな躯体と森の景色に目が奪われる、ゆったりとした空間。森厳な神社の気配は天井の梁や社殿を囲む玉垣の柱とほぼ同じ間隔で張りめぐらされた壁の大和張り（やまとばり）の規則性に取り込まれている。

The sharp interior of the main lobby and the forest scenery outside are a feast for the eyes. The solemn atmosphere of the shrine is referenced in the building's design, including decorative planks in the walls based on a traditional technique called *yamato-bari*.

1階の「杜の展示室」では、明治神宮が過ごす百年、一年、一日、一刻という4つの時間軸を切り口に、明治神宮の歴史と日々の営み、杜と祈りを永続させる精神とをわかりやすく展示している。

The Forest Exhibit Room shows the life of Meiji Jingu through the lens of 4 different time segments: 100 years, 1 year, 1 day, and 1 moment. In this way, the exhibits are able to depict the history, the day-to-day work, and the undying spirit of the shrine.

金色の鳳凰の彫刻をいただく馬車は英国製の国儀車。1889（明治22）年2月11日の憲法発布日、青山練兵場（現・神宮外苑）における観兵式に明治天皇・昭憲皇太后が行幸啓（ぎょうこうけい）になり乗車した六頭曳（ろくとうびき）儀装車。

This ceremonial carriage, made in England and topped with the image of a golden phoenix, was used to convey Emperor Meiji and Empress Shoken in a parade that was held in the Outer Gardens on February 11, 1889 in celebration of Japan's constitution.

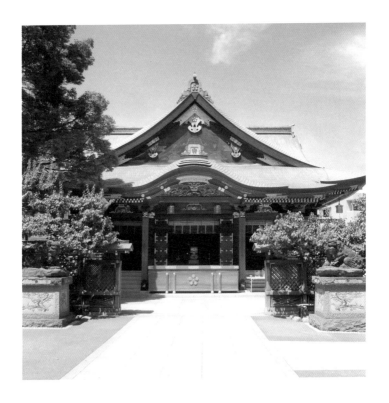

❾ 湯島天満宮（湯島）

458（雄略天皇2）年、勅命により創建と伝えられ、天之手力雄命を祀ったのがはじまり。その後、1355（正平10）年に土地の人々が菅原道真公（菅公）の御偉徳を慕って、文道の大祖と崇めて本社に勧請し、併せてお祀りした。さらに1478（文明10）年に太田道灌がこれを再建し、1590（天正18）年、徳川家康公が江戸城に入ると、ことのほか本社を篤く崇敬して、翌1591年豊島郡湯島郷に社領地を寄進した。「これをもって祭祀の料にあて、泰平永き世が続き、文教が大いに賑わうように」と、菅公の遺風を崇めたという。その後、さまざまな学者・文人の参拝も絶えることなく続いた、さらに将軍徳川綱吉公が湯島聖堂を昌平坂に移すと、この地を文教の中心として湯島天満宮をいっそう崇敬し、今もなお崇拝され続けている。現社殿は1995（平成7）年、後世に残る総檜造りで造営された。毎年2月には道真公がこよなく愛した梅の花が境内を彩り、「梅まつり」が開催され大いに賑わう。

㉗6:00〜20:00（授与所 8:30〜19:30）　㉛03-3836-0753　㉔無休　㉕文京区湯島 3-30-1　㋐地下鉄湯島駅徒歩2分・上野広小路駅徒歩7分・JR御徒町駅徒歩8分　㋒yushimatenjin.or.jp

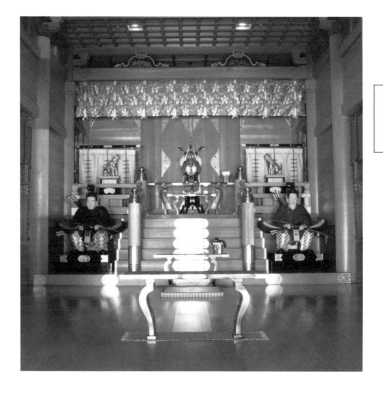

❾ YUSHIMA TENMANGU (Yushima)

Yushima Tenjin was established by imperial edict in 458 and the god Ame-no-Tajikarao-no-Mikoto was enshrined there. Several centuries later, in 1355, Sugawara Michizane was also enshrined at there to be worshipped as a god of learning and knowledge. Ota Dokan rebuilt the shrine in 1478, and Tokugawa Ieyasu was a loyal patron of the shrine, donating land in 1591 and holding a festival to pray for peace and promote culture and education in the spirit of Michizane. Through the years, Yushima Tenjin has been a popular destination for scholars and writers such as Hayashi Doshun, Matsunaga Shakugo, Hori Kyoan, Priest Gyoe, and Hakuseki Arai. After Shogun Tokugawa Tsunayoshi moved Yushima Seido Hall to Shohei Hill, this became a center of learning and culture, and the shrine's patronage increased even more. Prior to the Meiji Restoration (1868), Toeizan Kaneiji in Ueno used to function as *betto* (a temple within a shrine) and appointed Kiken-In to manage the temple affairs. The current shrine building was constructed in 1995 from 100% *hinoki* cypress.

Ⓗ 6:00~20:00 (Shrine Office 8:30~19:30) Ⓣ 03-3836-0753 Ⓒ Open Year-round Ⓐd 3-30-1 Yushima, Bunkyo-ku Ⓐc 2-min walk from Yushima Metro Station, 7-min from Ueno-Hirokoji Metro Station, 8-min walk from JR Okachimachi Station Ⓤ yushimatenjin.or.jp

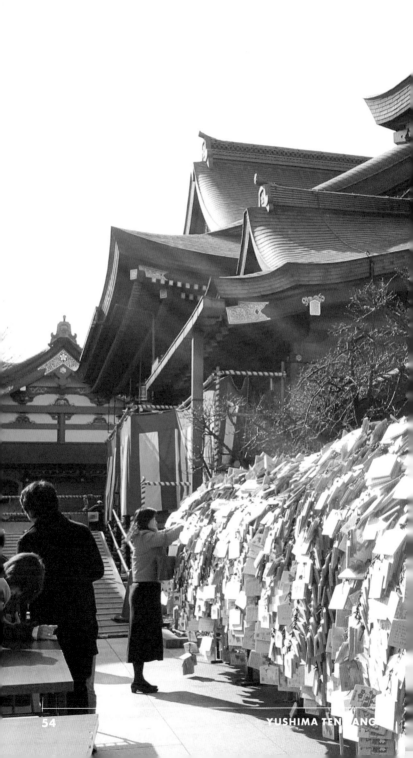

YUSHIMA TENJANG

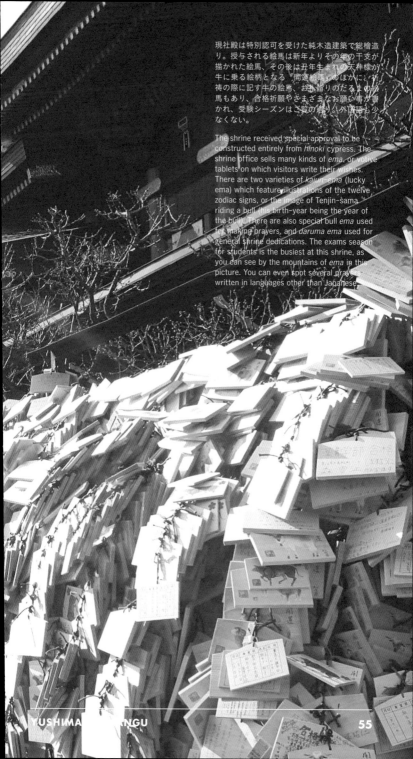

現社殿は特別認可を受けた純木造建築で総檜造り。授与される絵馬は新年よりその年の干支が描かれた絵馬、その後は丑年生まれの天神様が、牛に乗る絵柄となる「開運絵馬」のほかに、祈祷の際に記す牛の絵馬、お礼詣りのだるまの絵馬もあり、合格祈願やさまざまなお願い事が書かれ、受験シーズンはご覧の通り、外国語も少なくない。

The shrine received special approval to be constructed entirely from *hinoki* cypress. The shrine office sells many kinds of *ema*, or votive tablets on which visitors write their wishes. There are two varieties of *kaiun–ema* (lucky ema) which feature illustrations of the twelve zodiac signs, or the image of Tenjin-sama riding a bull (his birth-year being the year of the bull). There are also special bull *ema* used for making prayers, and *daruma ema* used for general shrine dedications. The exams season for students is the busiest at this shrine, as you can see by the mountains of *ema* in this picture. You can even spot several prayers written in languages other than Japanese.

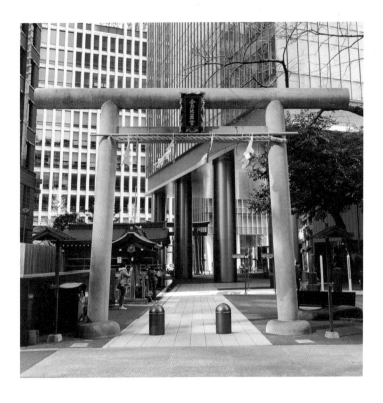

❿ 虎ノ門金刀比羅宮（虎ノ門）

官庁街、オフィス街の一角に現れる、総尾州檜造り、銅板葺きの拝殿と幣殿を連ねた堂々たる権現造り。ランチタイムにはキッチンカーや定食屋を目指して行き交う人々が、霊鳥霊獣の四神をまとう銅鳥居の前で一礼したり、御百度石をさすったりと、心を配って通る光景が眺められる。江戸時代に伊勢参りと人気を二分したこんぴら参り。その讃岐国丸亀の藩主・京極氏が江戸の藩邸に大物主神を祀る本宮の御分霊を勧請し、後に江戸城三十六城門の一つ、裏鬼門にあたる虎ノ門に遷座すると、投げ銭をする人が後を絶たず、毎月10日に邸内社を開放した。縁日となり金刀比羅大権現の幟と老若男女の押し合う様子は歌川広重の「江戸名勝図会」にも残り、戦後は露店が新橋まで並んだ。現在は神楽奉納が鑑賞できる。また良縁を求める女性が髪や折り紙を結ぶ末社の結神社も良縁祈願で有名。社殿は日本最初の建築史家、伊東忠太の（設計）校閲。

(時) 9:00 〜 17:00（土・日・祝〜16:00）　(電) 03-3501-9355　(休) 無休　(住) 港区虎ノ門 1-2-7　(ア) 地下鉄虎ノ門駅徒歩1分・霞ケ関駅徒歩5分　(ウ) kotohira.or.jp

⑩ KOTOHIRA-GU (Toranomon)

Toranomon Kotohira-gu is located amidst a bustling business district, a magnificent traditional shrine made with 100% *hinoki* lumber and sheet copper roofing. Kotohira-gu runs a food truck at lunch time, and many a businessman can be seen bowing reverently at the copper *torii* gate or touching the *ohyakudo-ishi* stone for luck on their way to and from the office. During the Edo period, this shrine vied with Ise Shrine in popularity. Originally from the Marugame domain, the feudal lord Kyogoku prayed for the establishment of a second shrine dedicated to Omononushi, and so Kotohira-gu was established in the unlucky quarter of Edo Castle. From then on, the donations flowed into the shrine, and the grounds were opened to the public on the 10th of each month. In Utagawa Hiroe's collection of illustrations, *Famous Locales of Edo*, you can see depictions of the god Konpira-daigongen and the jostling crowds of men, women, young and old who came to the shrine for festivals. The shrine's design was overseen by Chuta Ito, Japan's first Historian of Architecture.

(H) 9:00~17:00 (weekends and holidays ~16:00) (T) 03-3501-9355 (C) Open year-round (Ad) 1-2-7 Toranomon, Minato-ku (Ac) 1-min walk from Toranomon Metro Station, 5-min walk from Kasumigaseki Metro Station (U) kotohira.or.jp

神社仏閣豆知識：仏閣編

お寺とは？

本来は釈尊（仏陀）の悟られた教えを学ぶ場所。僧伽と呼ばれる僧侶が修行していた建物に信者が仏の教えを乞うため足を運ぶようになり寺院という形に変成してきた。日本にはもともと神道信仰があり、自然そのものが御神体で聖域。伝来した仏教は、土地を神様にお借りして伽藍（寺院）を建て、境内には本堂以外に御社を建て御神体を奉祀し、そんな神仏習合は自然なことであった。明治期の神仏判然令（神仏分離令）により、寺院と神社は分けられた。

宗派の違いは？

奈良時代の南都六宗を皮切りに、現在は華厳宗、法相宗、律宗、真言宗、天台宗、日蓮宗、浄土宗、浄土真宗、融通念仏宗、時宗、曹洞宗、臨済宗、黄檗宗に大別される。お釈迦様は教えを記し残すことはされなかったが、一人ひとりにそれぞれの教えを説かれ、その法門は八万四千を優に超えている。それを伝え聞いた弟子が経典として残し、伝承されてきた。どの経典を用いて修行を行うのか（例えば、坐禅や瞑想、加持祈祷や称名念仏など）が日本の宗派の違い。人々から苦しみを除き、世界を平和にするという目標は同じ。

仏像にはどんなものがある？

2500年ほど前に実在された仏教の開祖である仏陀を基にした釈迦如来をはじめ、大日如来や阿弥陀如来、明王、菩薩、諸天（神様のこと）などの仏像のほかに、各宗派の宗祖・高僧なども代表的。即身仏（修行僧が、人々を救いたいとの願いを込めて諸仏に祈りながら、行者自身で準備し、衆生救済、例えば、木食・断食などをし、身体を留めたまま仏と一体となった成仏した姿）等の貴重な仏像もある。

正しい参拝の仕方は？

山門前で合掌して一礼。門をくぐり本堂や諸堂に向かい、線香立てや灯明立てがあればお供えをして合掌。外にない場合は堂内にあることも。本堂や諸堂に入れる場合は靴を脱いで入り（ほとんどが土足禁止）、本尊に向かって合掌礼拝する。また、基本のお供えである御香・灯明・花の他にお賽銭も供えて。順番として最初に本堂、次に諸堂やお墓にお参りすることが理想だが、混雑していればその限りではない。何よりも心を込めてお参りすることが一番大切。

取材協力：下島章裕さん（全日本仏教会）

TRIVIA ABOUT BUDDHIST TEMPLES

WHAT ARE TEMPLES?

Originally, temples were places where the teachings of the Sakyamuni Buddha were taught. When believers in Buddhism began coming to the places where Buddhist monks practiced to learn these teachings, they became something closer to the temples we see today. Japan's native religion, Shinto, believed nature itself to be the manifestation of the *kami*. When Buddhism came to Japan, temples were built with the understanding that they were borrowing the land from the *kami*, and shrines were established within temple grounds in their honor. With the Meiji-era decree to separate Shinto and Buddhism, shrines and temples were completely separated.

DIFFERENCES BETWEEN SECTS

Six sects of Buddhism were brought to Japan in the Nara period (710-794), and the religion has since expanded into the 13 primary sects of modern Japan. The Buddha left no records, but his teachings were recorded by disciples in sacred tomes called sutras. Each sect is differentiated by which sutra guides its practices (e.g. *zazen* and *meiso* meditation, incantation and prayer, etc). However, the guiding principle of saving people from suffering and promoting peace remains the same across all sects.

DIFFERENT KINDS OF BUDDHIST IMAGES

Buddhist statues modeled after Siddhartha, the progenitor of Buddhism, are called *shaka-nyorai* in Japanese. There are many other images, including *dainichi-nyorai, amida-nyorai, myoo, bosatsu, shoten*, and images of sect founders and high priests, as well as *sokushinbutsu* and *danjiki*.

THE PROPER WAY TO WORSHIP

It is customary to join your hands and bow at the temple gate before entering. On your way to the main hall you may find places to offer incense or candles. First make your offering, then join your hands in prayer. When entering halls, it is customary to remove your shoes, and once inside worshippers are to face the *honzon* and join their hands in prayer. Visitors make offerings of incense, candles, and flowers, as well as monetary offerings. Normally, you first visit the main hall, then the lesser halls and gravesite, but this can be difficult when a temple is crowded. More than such customs, it is important that you approach the temple with an earnest and sincere attitude.

*Special thanks to Mr. Akihiro Shimojima (All Japan Buddhism Association)

東京の神社仏閣、見逃せない祭・縁日・年中行事

FESTIVALS AND ANNUAL EVENTS AT SHRINES AND TEMPLES

祭・縁日・年中行事は神社仏閣の特別な日。
いつもと違う、賑やかな雰囲気を堪能できる

日本人の暮らしに根づいた伝統行事たる「年中行事」。神仏を祀って祝う季節の「祭礼」。そして、神仏ごとに由来ある日で、この日参拝すれば、特別なご利益があるとされる「縁日」。それらの時期限定の露店が並ぶ「門前市」。いずれも、東京の神社仏閣を彩る特別な日で、お参りに訪ねた境内は、普段とはまた違う美しさ、興味深さに満ちている。また、それぞれの日にのみ授与される「縁起物」は、どれも工夫を凝らした味わい深い意匠。もちろん特別なご利益もあり、忘れず手にしたいものの一つ。この日に合わせて東京の神社仏閣を訪れれば、貴重な体験ができそう。

Enjoy a Festive Atmosphere at These Normally Solemn Locations

Traditional annual events called "*nenkan-gyoji*" are an important part of life for the Japanese. Among these are religious festivals called "sairei" that are meant to celebrate both *kami* and Buddha. There are also days called "*ennichi*," which can derive from either Shinto or Buddhist origins, and which are supposed to bestow visitors who come on such days with special blessings. Special stalls called "*monzen-ichi*" are erected on such days. Both *sairei* and *ennichi* are special religious days during which you can see a rare, festive side to shrines and temples. You can also buy special talismans and charms called "*engimono*" on these days, any of which are guaranteed to be the work of skilled craftsmen. These charms are imbued with special blessings as well, so you won't want to forget to get one while you're enjoying the festivities. Plan your trip to Tokyo around these days and you'll be sure to have an unforgettable experience.

※ここでご紹介する年中行事などは、すべての神社仏閣で行われるものではありません。また、「酉の日」のように、干支で年月を表す古い暦で日程を決める行事の場合、毎年日付が変わります。お出かけの際には、事前に神社仏閣のホームページなどでご確認ください。

*Be aware that the annual events introduced here are not necessarily observed at every shrine and temple. Also, special days determined by the old lunar calendar (*tori no hi* "day of the rooster," etc.) are different from year to year. Be sure to check shrine and temple websites before heading out to make sure you don't go on the wrong day.

七福神詣

近隣7カ所の寺や神社を巡って神様をお参り、その証に御朱印等をいただく七福神詣は、江戸で大流行、今に続く初詣の一形態。江戸最古の「谷中七福神」をはじめ、都内には30を超えるコースがある。七福神は、恵比寿、大黒天、毘沙門天（びしゃもんてん）、弁財天、福禄寿、寿老人、布袋の7柱。この時期のみご開帳の神様も多数で、そのお姿を拝むのも楽しみの一つ。

元旦〜7日他

New Year's Day ~ January 7

SHICHIFUKUJIN-MODE

Shichifukujin-mode is the practice of visiting 7 shrines in honor of the Seven Lucky Gods (*shichifukujin*) and receiving each shrine's seal (*goshuin*). This form of *hatsumode* was popular during the Edo period and is still practiced today. The oldest course is the *yanaka-shichifukujin*, but there are over 30 different courses. The seven gods are Ebisu, Daikokuten, Bishamonten, Benzaiten, Fukurokuju, Jurojin and Hotei.

吉凶のないおみくじ

おみくじは吉凶を占うのが一般的。しかし、明治神宮（p.44）のおみくじ「大御心（おおみごころ）」は、吉凶の代わりに、運勢を和歌で表す様式が、味わい深く、人気がある。神紋である菊の透かし模様を配した和紙に、御祭神・明治天皇の御製（ぎょせい）と昭憲皇太后の御歌（みうた）を15首ずつ、計30種類。裏面に解説と英訳付き。持ち帰って、折々に意味を考え暮らしの糧にするスタイル。

OMIKUJI WITHOUT FORTUNES

Omikuji lots tell you if your fortune will be good, bad or otherwise. Meiji Jingu, however, offers *omi-gokoro*, special lots that have a Japanese poem written on them. The ability of readers to interpret their fortune through these poems is one of the reasons they are so popular. Each is embossed with the imperial chrysanthemum seal, and the poems featured were written by Emperor Meiji and Empress Shoken. Feel free to take yours home and revisit the poem. It's sure to offer wisdom and clarity.

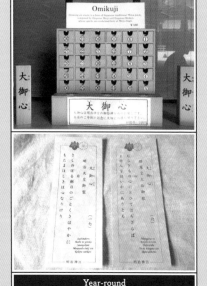

通年

Year-round

鷽替えの神事と木鷽

天神様の新年最初の縁日「初天神」。この日、天神様ゆかりの鷽鳥を象った「木鷽」を境内で取り替える「鷽替えの神事」が行われる。昔は「替えましょ、替えましょ」と言いながら、参拝者たちが手から手へと取り替えたとされる。現在は、古い木鷽を神社に返し、新しいものを授与いただく形式に。写真は湯島天満宮（p.52）の木鷽。天神様ごとの意匠違いが楽しい。

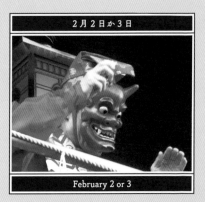

1月25日他 / January 25

THE CHANGING OF THE BULLFINCH

On the day of Hatsu-tenji, wooden carvings of the Japanese bullfinch (a bird associated with Tenjin-sama) called *kiuso* are replaced all around the shrine. In the past, visitors would pass the wooden bullfinches around while chanting, "replace them, replace them." Today, visitors return their old bullfinches in exchange for new ones. The photo on page 52 shows the *kiuso* of Yushima Tenmangu Shrine.

節分祭

冬と春を分ける「節分」の日。日本の家庭で「福は内、鬼は外」と豆まきが行われるように、この日、多くの神社仏閣で「節分祭」が執り行われる。豆まきの前に、伝統的な鬼祓いの儀式が行われることも多く、弓矢で厄災を祓う儀式や、鬼と神職の問答が行われたりと興味深い。豆で追われる鬼の、お面の意匠が素晴らしく、逃さず鑑賞したいものの一つ。

SETSUBUN FESTIVAL

The day winter turns to spring is called Setsubun, when households around Japan perform a ritual called mamemaki." Setsubunsai is also held at shrines and temples on this day. Before the *mamemaki* a number of rituals are performed, including the expelling of misfortune by bow and arrow and interesting dialogues between demon and priest. The craftsmanship of the demon masks used in the *mamemaki* ritual is truly remarkable.

2月2日か3日 / February 2 or 3

福豆

節分祭が近づくと、神社仏閣ごとに「福豆」の授与が始まる。「福豆」は、節分にまく煎り大豆のこと。早めに授与いただき、神棚などに供え、節分の日を待つのが作法とか。美しい和紙に包まれたり、枡に入れられたりと、その意匠にも工夫があって楽しい。写真は根津神社の「福豆」。豆まきが終わったあとの「福豆」は、年齢の数だけ食べて無病息災祈願。

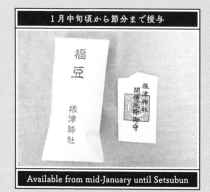

１月中旬頃から節分まで授与

福豆

根津神社

根津神社
開運福豆御守

Available from mid-January until Setsubun

FUKUMAME BEANS

As Setsubun approaches, shrines and temples begin to sell *fukumame*, bags of roasted beans to be used for *mamemaki*. It is customary to buy these beans as early as possible, set them before your household shinto shrine as offering and wait for Setsubun to come. The beans are wrapped in beautiful washi paper or unique *masu* containers. The photograph shows Nezu Shrine's *fukumame*. Leftover *fukumame* can be eaten--they say you will be healthy if you eat as many beans as years you've lived.

初午祭の火防（ひぶせ）の凧

２月はお稲荷さんの「初午祭」。江戸市中は火事が悩みの一つだったから、江戸東京の稲荷社のご利益には「火防」が多い。そんな由来で王子稲荷神社の初午祭では、奴（やっこ）の「火防の凧」が授与いただける。使者の狐たちが、王子稲荷へ参るのに着替えた場とされる装束稲荷神社も併せてお参りし、「火防の凧」を２ついただけば、現代の防火対策も万全。

HATSU-UMA FESTIVAL AND HIBUSE NO TAKO

The Hatsu-uma Festival is held in February, an important rite of Oinari-san (the fox god). Fires were common in old Edo, which is why one of the blessings you could receive from Inari shrines in Tokyo was protection from fire. Oji-Inari Shrine, for example, sells *hibuse no tako* (kite-shaped charms that protect from fire) during the Hatsu-uma Festival. If you go to Shozoku Inari Shrine as well, you can get two of these wonderful charms!

２月午の日

Day of the Horse in February

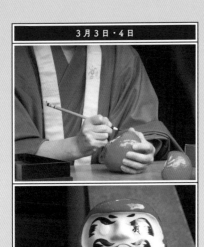

3月3日・4日

March 3-4

深大寺のだるま市

深大寺（p.10）のだるま市は、日本三大だるま市に数えられるほど盛大。境内の露店に並ぶおびただしい数のだるまのなかから、好みの一体を求め、今年の祈願成就を見守るお守りとして持ち帰る。だるまには、まず左目を入れるのが作法だが、僧侶から梵字の「阿（あ）」の目を入れていただくのが深大寺流。翌年、右目に梵字の「吽（うん）」を入れ、寺に納めるのも大事な作法。

DARUMA MARKET AT JINDAIJI TEMPLE

Jindaiji's daruma market is one of the top three in Japan. Visitors comb the various stalls selling innumerable daruma dolls for just the right one, and when they've found it they take it home as a lucky charm to bring their deepest hope to fruition. It is common practice to fill in the left eye of your daruma first, but Jindaiji has a unique custom of filling the eye in with the sanskrit letter for "a." The following year, you fill in the right eye with the sanskrit letter "un" before dedicating the daruma doll to the temple.

長命寺の桜餅

江戸風「桜餅」は、薄く焼いた餅皮に餡を挟み桜の葉で包んだもので、向島の長命寺門前が発祥。創業者・山本新六は、この寺の門番だった際、夥しい量の桜の落葉の有効活用を考える。そして、1717（享保2）年に土手の桜の葉を塩漬けにして餅を包み「桜餅」として長命寺門前で売り大ヒット。大きな桜の葉で包まれた桜餅には、発祥の風格がある。

SAKURAMOCHI AT CHOMEIJI TEMPLE

Sakuramochi, popular in the Edo period, is a thin layer of lightly roasted mochi filled with red bean paste wrapped in a sakura leaf. This delicious snack originated at Chomeiji after Shinroku Yamamoto thought of a way to use the sakura leaves that fell each year. In 1717, he pickled the leaves in a salt solution and wrapped mochi with them. They became a huge hit when he began selling them in front of the temple.

通年

Year-round

灌仏会 <ruby>灌仏会<rt>かんぶつえ</rt></ruby>

お釈迦様の誕生を祝う「灌仏会」。仏教寺院には美しい花御（はなみ）堂。中央に、お誕生の姿をとされるお釈迦様が配され、参拝者は、その釈迦像に甘茶を注いでお参りをする。これは、ルンビニの花園で生まれたお釈迦様に天から清浄の水が注がれたという降誕伝説に由来。寛永寺（p.40）の境内だった上野恩賜公園には、写真の開山堂ほか花御堂を配す寺院が点在。

4月8日

April 8

KANBUTSUE, BUDDHA'S BIRTHDAY

"Kanbutsue" is the day we celebrate Buddha's birthday. A special structure called the "*hana-mido*" or "flower shrine" is featured in this celebration. In the center is placed the image of Buddha as he was born, and worshippers come and pour hydrangea tea over it. This is a sort of reenactment of the legend of the Buddha's birth, as he was supposedly born in a flower garden in Lumbini and bathed in pure water from the heavens. Within Ueno Park are several temples where *hana-mido* are placed, including Kaneiji (p.40).

富士塚開山式と麦藁蛇 <ruby>麦藁蛇<rt>むぎわらじゃ</rt></ruby>

東京各所に点在するミニチュア富士「富士塚」は、江戸時代に大流行した「富士信仰」の名残。本物の富士山に併せ、富士塚でも開山式が執り行われる。多くは、神事ののちに富士塚を登拝するスタイル。この日、授与される「麦藁蛇」は、麦藁細工で蛇を象った意匠が面白い。水場に祀り、疫病・水あたりよけとする。写真は、浅草富士浅間神社のもの。

MINIATURE FUJI'S AND STRAW SNAKES

"Fujizuka" are miniature mounds that are meant to represent Mt. Fuji, popular in the Edo period and a lingering remnant of *fuji-shinko*, or the "faith of Fuji." These miniatures are used in shrine opening ceremonies, often coming after the kamigoto rituals. On these days you can purchase "*mugiwaraja*," snake dolls made from barley straw. They are placed near water and are meant to ward off pestilence. The *mugiwaraja* photographed here is from Asakusa Fuji Sengen Shrine.

6月30日・7月1日他

June 30-July 1

天下祭（神田祭／山王祭）

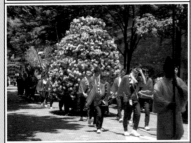

隔年で5月中旬（神田祭）/6月中旬（山王祭）

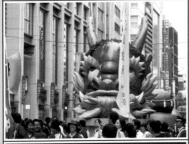

Mid-May (Kanda Festival) and Mid-June (Sanno Festival)

5月の大型連休が明けると、東京は夏祭りの季節。特に見逃せないのが、「天下祭」と呼ばれる神田明神（p.106）の神田祭と日枝神社（p.82）の山王祭。天下祭という呼び名の由来は、この二社のみ、祭の山車が江戸城に入ることを許されて、将軍が上覧したことによる。今も雅な装束をまとった人々による祭礼行列が都内を巡り、そのあとにユニークな意匠の山車が続く。

TENKA-MATSURI (KANDA FESTIVAL AND SANNO FESTIVAL)

As May holidays end, Tokyo enters festival season. Festivals you won't want to miss are Kanda Festival held at Kanda Shrine (p.106) and Sanno Festival held at Hie Shrine (p.82). These festivals are popularly called "*Tenka-matsuri*," a reference to the fact that they were the only festivals with floats admitted into Edo Castle for the Shogun to see. To this day, these festivals are a sight to behold, featuring a procession of elegantly clad performers and unique floats.

入谷鬼子母神の朝顔市

「朝顔市」は東京下町の夏の風物詩。入谷鬼子母神（真源寺）とその門前の言問通り沿いに、朝顔の露店がずらり並び、早朝から夜間まで「入谷朝顔まつり」が続く。市に並ぶ朝顔は、つるを行灯型の支柱にはわせた「行灯仕立て」が主流。青・紫・赤紫など基本の色合いに加え、珍しい濃茶色の団十郎朝顔、白い夕顔なども並ぶ。花が元気な早朝に訪れるのがおすすめ。

SHINGENJI'S MORNING GLORY MARKET

The *Asagao-ichi* is a staple of summer in Tokyo's *shitamachi*. Kototoi Road extends from Shingen Temple's gate, and in the right season you'll see it lined with stalls for the Iriya Asagao Festival. The "*andon-jitate*" (pictured) allow the vines of the morning glory to grow along a wooden structure modeled after paper lanterns. We recommend visiting in the early morning when the flowers are the most vibrant.

7月6〜8日

July 6-8

浅草寺のほおずき市

「ほおずき市」のほうが有名だが、実際は、浅草寺（p.28）の縁日「四万六千日（しまんろくせんにち）」の門前市という関係。この日、観音様をお参りすると46000日分のご利益があるとされる。お参りしたら、瑞々しいほおずきが並ぶ露店を眺めて、気に入りの一鉢を。この時期、ほおずきを求めるのはお盆の準備。東京ではひと月早くお盆の日々がやってくる。

写真提供：浅草寺

7月9・10日

July 9-10

Picture used with permission from Sensoji Temple

SENSOJI TEMPLE'S HOZUKI MARKET

The *Hozuki-ichi*, or lantern-flower market, is quite famous, but it is actually part of a larger event, an *ennichi* called "Shimanrokusen-nichi" (46,000 days). It is so-called because visiting Kannon on this day is said to give 46,000 days' worth of blessings. You'll also see a number of stalls selling vibrant *hozuki*, or Japanese lantern flowers. These plants are meant to be in preparation for the *obon* holidays, which are held one month earlier than other parts of Japan.

芝大神宮のだらだら祭と千木筥（ちぎばこ）

芝大神宮の例大祭は、祭期がだらだら長いので通称「だらだら祭」。お伊勢参りブームを受けて、江戸のお伊勢様たるこの社の参拝者が増加。それに併せ、少しずつ祭期が延びたとか。ここで授与される「千木筥」は、白木に白・紫・緑で藤の絵が描かれた小さな弁当箱風の三段重ね。麦わらの縒り紐でキュッとくくった粋な意匠。縁起物のなかでも人気のひとつ。

SHIBA DAIJINGU'S DARADARA FESTIVAL

Shiba Daijingu Shrine holds a festival popularly called Daradara Festival. As a branch of Ise Shrine in Tokyo, the shrine gained immense popularity due to the popularity of the Ise Pilgrimage. They say the shrine began to slowly lengthen the festival in order to capitalize on this popularity. The "*chigibako*" (pictured) is a bento-shaped wooden box featuring beautiful illustrations of white and purple wisteria.

9月中旬

Mid-September

菊まつり

特に湯島天満宮 (p.52) の菊まつりは、菊細工の要素がいろいろと楽しめて魅力的。「千輪咲き」等の「細工物」、菊花だけで大きな絵を描いたような「盆庭」。菊で着物を飾る「菊人形」。江戸時代から伝わる「古典菊」の展示も。

KIKUMATSURI

Yushima Tenmangu's (p.52) Chrysanthemum festival is one of the best, with a variety of chrysanthemum crafts from *senrinzaki* (thousand blossoms) to *bontei* which depict grand pictures. There are also chrysanthemum dolls and beautiful *kotengiku*, an art passed down from the Edo period.

11月上・中旬他

Early to Mid-November

酉の市と熊手守

都内の大鳥神社（鷲神社）の門前に、華やかな「飾り熊手」の露店が並ぶのが、馴染みの光景。一方、神社から授与される「熊手守」は知る人ぞ知る小さな熊手型のお守り。竹製の熊手に施された細かな工夫が興味深い。

TORI-NO-ICHI & KUMADE CHARMS

Otori Shrine is known for the stands that line the road before the gate. These stands sell "*kazari-kumade*" (decorative rakes) as well as "*kumade-mamori*," the shrine's little-known secret. The craftsmanship that goes into them is truly a marvel.

11月酉の日

Day of the Rooster in November

写真提供：浅草寺

12月17〜19日

December 17-19

Picture used with permission from Sensoji Temple

浅草寺 (p.28) の羽子板市

羽子板市は「納めの観音」の門前市。昔は正月用品の市で羽子板のみが今に伝わる。羽子板は「邪気を跳ね返す板」。突羽根は、先端の玉を「無患子（むくろじ）」という木の実で作り、「無患子＝子が患わない」などの意味を込める。

HAGOITA MARKET

The Hagoita Market is the final celebration of Kannon for the year, held before the Sensoji's gate. Originally, goods relating to the new year were sold, but only the *hagoita* have been passed down from ancient times.

68

穴八幡宮の一陽来復御守

金柑・銀杏各 1 個ずつを包み「一陽来復」と書いたシンプルな意匠が美しい。ご利益が「金銀融通」＝「金運アップ」のせいか大人気。祀る作法が超厳密で、冬至・大晦日・節分のいずれかの深夜 0 時に恵方を望む高所に貼る。

ANAHACHIMANGU SHRINE'S OMAMORI

Ichiyo-raifuku omamori are special charms with a simple but beautiful design. These *omamori* bring good fortune in finance, so they are naturally popular. *Ichiyo-raifuku omamori* must be placed in a high location facing a favorable direction at midnight on the winter solstice, New Year's Eve, or *setsubun*.

冬至から節分まで授与

Available from Winter Soltice through Setsubun

神社仏閣を彩る花々

1 月は上野東照宮の冬牡丹が見頃で、天神様の梅も開花。というように神社仏閣ごとに季節の花を覚えておくと楽しい。桜が散れば、根津神社 (p.78) のつつじ。後を追って、亀戸天神の藤……境内花リレーは晩秋まで続く。

FLOWERS AT SHRINES & TEMPLES

January is the perfect time to see Ueno Toshogu's winter peonies and the plum blossoms of Tenjinsha. After the sakura have fallen, you can see the rhododendrons of Nezu Shrine. And after that there are the wisteria of Kameido Tenjin Shrine, and a number of sequentially blooming flowers that continue through late autumn.

季節ごとに

Seasonal

神社や寺で逢える動物たち

神社仏閣での動物探しも面白い。たとえば、神社を守る狛犬や稲荷神社の狐。天神様の牛。日枝神社 (p.82) や浅間神社の猿。寺院の山門等に彫られる十二支を入れると切りがない。多くは神仏の使者で、その由来も興味深い。

ANIMALS AT SHRINES & TEMPLES

Looking for animals, the envoys to *kami* and Buddha, is yet another way to enjoy temples and shrines. *Komainu* dogs guard shrine entrances, and foxes frolic around Inari Shrine. You can find oxen around Tenmangu and monkeys at Hie (p.82) and Sengen Shrines.

通年

Year-round

PART_3

東京の歴史や風土に触れる

HISTORY AND CULTURE OF TOKYO

武士道に生きた歴史舞台の名刹へ。
自身と向き合い心落ち着くひとときが至福

10代の頃、ホームステイで訪日し、庭のある純日本家屋のお宅で過ごし、毎朝仏壇に手を合わせ、また伝統文化を大切にする日本人の気持ちに心を打たれたという村雨さん。それから冒険心の赴くままに、いまや日本人庭師として活躍中だ。「歴史が好きなんです。日本の庭園からは、その背景や時間の流れを識ることができます。そんな庭を見るため、また、歴史的事件のあった場所で人物に思いを馳せて散策するために、お寺や神社を訪れます」。東京に来て真っ先に訪れたのは泉岳寺。「僕は吉良派で、士分でないのに取り立ててくれた主君を守るため命を捨てた清水一学（しみずいちがく）さんに一番武士道を感じて、物語に触れたくて。愛宕神社も出世の石段や桜田門外の変など武士の哲学に縁があり、気持ちが引き締まりますね」。また、帝釈天題経寺（たいしゃくてんだいきょうじ）は立派な門被（もんかぶ）りの松と、愛される寅さんの町の風情まで楽しめてお気に入りの場所なのだそう。

Temples, the Stage for a History Steeped in the Warrior Culture of Bushido
Look inward and enjoy a moment of sublime peace

Tatsumasa Murasame fell in love with Japan during his homestay as a teenager. He has followed this love ever since, and now works as a Japanese gardener. "You can see the progression of history through Japanese gardens. I visit temples and shrines to see just such gardens and to contemplate the historical events that occurred there." Murasame visited Sengakuji Temple before any other temple in Tokyo. "I was interested in the temple's connection to the *47 ronin*. I'm a fan of the Kira clan and feel the spirit of bushido most from Shimizu Ichigaku, who gave his life to protect his master even though he was not of samurai status. Atago Shrine also has some connection to bushido and the Sakuradamon Incident. These connections really draw me in." Another interesting temple is Taishakuten Daikyoji Temple, famous for its connection to the beloved film character Torasan.

ARTRIP ADVISER	庭師。スウェーデン出身。世界史で習う日本に興味を抱き、日本語を勉強。16歳の時にホームステイで日本人と生活文化に触れて、19歳で日本移住。伝統的な徒弟制度に興味をもち、26歳の時に愛知県の加藤造園に弟子入りし、帰化。現在は独立。TV出演でも話題に。
 村雨辰剛さん Tatsumasa Murasame	Gardener. Originally from Sweden. Moved to Japan at 19 and, at 26, became an apprentice at Kato Landscaping and gained Japanese citizenship. He works independently now, and has even appeared in some Japanese TV programs.

71

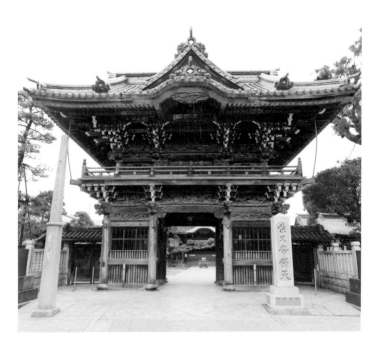

⓫ 帝釈天題経寺（柴又）
たいしゃくてんだいきょうじ

1629（寛永6）年に日蓮宗の下総中山法華経寺の日忠上人が開山し、その弟子の
しもうさなかやまほっけきょうじ　にっちゅう
日栄上人が経栄山題経寺を開基。日蓮聖人が衆生の病をなくそうと願いをかけ
にちえい　きょうえいざん　しゅじょう
て刻んだ帝釈天を祀るも、江戸中期に所在不明に。1779（安永8）年に本堂改修
中の梁上に板本尊が出現し、まさに相伝の祈祷本尊の再来と、この法悦の吉日
いたほんぞん
が庚申だったことから、庚申の日は縁日に。板本尊は片面に『法華経』のお題
かのえさる
目と病を消滅する経文、もう一面に忿怒の相の帝釈天が彫られている。もとは
きょうもん　ふんぬ　そんぎょう
インド・バラモン教の悪魔降伏の尊形で、仏法の守護神。天明の大飢饉（1782–88
ききん
年）では疫病、飢饉が蔓延し、日敬上人が自らこの板本尊を背負って町の人々
を救済したという。こうして江戸を中心に帝釈天信仰が高まり、庚申日は帝釈
堂でご本尊の一番開帳を受け、御神水をいただいて家路につく宵庚申が大流行。
よいこうしん
今も年6回巡る庚申日には常開帳されている。

（時）9:00 ～ 16:00 （料）庭園邃渓園・彫刻ギャラリーのみ共通拝観料400円（12/28 ～ 1/3 はギャラリー
のみ 200円）（電）03-3657-2886 （休）無休（12/28 ～ 1/3 庭園休園）（住）葛飾区柴又 7-10-3 （ア）京成線
柴又駅徒歩 3 分、北総線新柴又駅徒歩 12 分 （ウ）taishakuten.or.jp

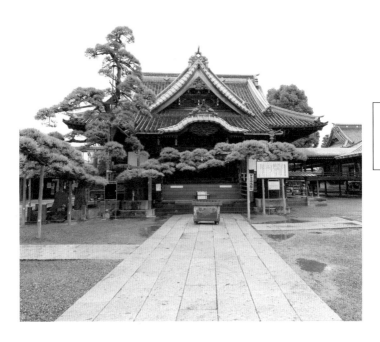

⓫ TAISHAKUTEN-DAIKYOJI (Shibamata)

Founded in 1629 by Priest Nicchu, the foundation was laid by his disciple Priest Nichiei. An image of Taishakuten was enshrined here with prayers to rid the world of illness, but it went missing in the mid-Edo period. It was rediscovered during the renovation of 1779, on a day called *kanoesaru*, a day which is now an *ennichi* for the temple. One side of the *honzon* shows excerpts from the Lotus sutra and prayers to eradicate illness; the other side shows a depiction of an enraged Taishakuten. Originally a deity of Brahmanism, Taishakuten later came to be a guardian deity in Buddhism. During the great famine of 1782-88, Priest Nichikyo carried this image all around town to save the people who were suffering. This made the faith of Taishakuten quite popular, and people visited the temple on the day of *kanoesaru* when the *honzon* was viewable to the public. To this day, it is made public every *kanoesaru*, (six times per year).

Ⓗ 9:00~16:00 Ⓕ ¥400 (Fee only required for Suikeien Garden and Gallery, and includes admission to both), 12/28-1/3 : ¥200 (Gallery only) Ⓣ 03-3657-2886 Ⓒ Open Year-round Ⓐ𝖽 7-10-3 Shibamata, Katsushika-ku Ⓐ𝖼 3-min walk from Keisei Line Shibamata Station, 12-min walk from Hoku-so Line Shin-Shibamata Station Ⓤ taishakuten.or.jp

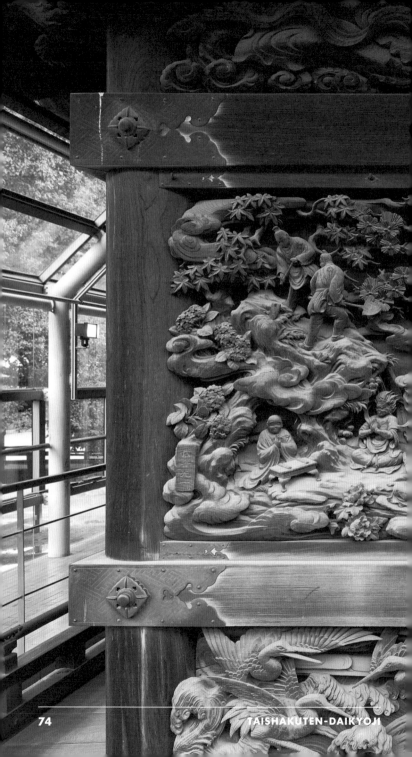

TAISHAKUTEN-DAIKYOJI

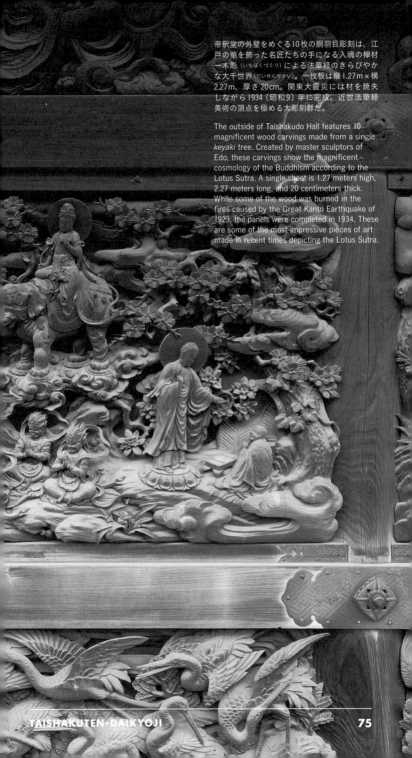

帝釈堂の外壁をめぐる10枚の胴羽目彫刻は、江戸の華を飾った名匠たちの手になる入魂の欅材一木彫（いちぼくづくり）による法華経のきらびやかな大千世界（だいせんせかい）。一枚板は縦1.27m×横2.27m、厚さ20cm。関東大震災には材を焼失しながら1934（昭和9）年に完成。近世法華経美術の頂点を極める大彫刻群だ。

The outside of Taishakudo Hall features 10 magnificent wood carvings made from a single *keyaki* tree. Created by master sculptors of Edo, these carvings show the magnificent cosmology of the Buddhism according to the Lotus Sutra. A single sheet is 1.27 meters high, 2.27 meters long, and 20 centimeters thick. While some of the wood was burned in the fires caused by the Great Kanto Earthquake of 1923, the panels were completed in 1934. These are some of the most impressive pieces of art made in recent times depicting the Lotus Sutra.

写真提供：帝釈天題経寺

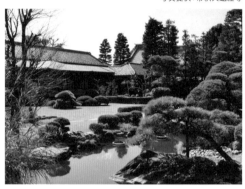

名匠・鈴木源治朗氏が材木一本から吟味した総檜造りの大客殿は1929（昭和4）年落成。対座する邃渓園（すいけいえん）は名庭師・永井楽山翁が戦前より手がけ、92歳まで心血を注いで1972（昭和47）年に完成した。

The 100% *hinoki* cypress Daikyakuden Hall, built by the master architect Genjiro Suzuki who handpicked each piece of lumber used, was completed in 1929, and the Suikeien Garden was designed by the great Nagai Rakuzan, who completed it at the age of 92.

写真提供：帝釈天題経寺

江戸寛永の昔、松の根方に霊泉の湧くのを見て、庵を結んだ題経寺の由緒ある御神水。こんこんと湧く慈悲の泉は御利益を授け、法華経に説く地涌（ちゆ）の水大（すいだい）を表す浄行（じょうぎょう）菩薩がこの世を清めてくれる。

Daikyoji Temple is said to originate here at the sacred water basin (*goshinsui*), where in the Edo period a holy spring was discovered here at the base of a pine tree, leading the people to erect a humble hut. They say this water is the sacred water of the Lotus Sutra, with which the bodhisattva Jogyo purifies the world.

日本の名作映画『男はつらいよ』の寅さんゆかりの門前町

The Neighborhood Made Famous by Torasan's *Otoko wa Tsuraiyo* Movie Series

京成線柴又駅に降りると、駅舎から山田洋次監督の映画『男はつらいよ』シリーズ（1969（昭和44）年〜。2019年に50周年で50作ある）の世界が広がる。駅前広場にはトランクをさげた旅姿の主人公、フーテンの寅こと車寅次郎、愛称 "寅さん" の像が出迎えてくれる。駅からすぐの「帝釋天参道」は、文字通り帝釈天題経寺に続く参道となっていて、まさに寅さんのテーマ曲が聞こえてきそうな人情味溢れる映画の舞台ともなった商店街が約200m続いている。軒先にかかる提灯、幟（のぼり）や看板など、明治・大正・昭和の建築のままの商店約40軒が軒を並べているその理由は、1996（平成8）年に主演の渥美清（あつみきよし）さんが亡くなった時に商店街と監督とで「寅さんが町に帰ってきた時に迷わないように」景観を残すことにしたためという。劇中の寅さんの実家は団子屋だったが、まさに草だんごや葛餅の老舗などの甘味処や川魚料理の食事処、仏具屋さんまで揃い、下町ロマンたっぷり。「この漬物、おいしいよ」と声をかけてくれて皆さん親切。寅さん愛に包まれる散策が楽しい。

Enter the world of director Yoji Yamada's *Otoko wa tsuraiyo* ("It's tough being a man") film series (1969–2019). A statue of protagonist Torajiro Kuruma, or "Torasan," greets fellow travelers outside of Shibamata Station. "Taishakuten Sando" leads up to Taishakuten Daikyoji Temple, and you can almost hear Torasan's theme playing as you make your way through this quaint shopping district. The shops here all maintain a retro feel with Meiji-, Taisho-, and Showa-era architecture and lanterns, banners and signboards hanging from the eaves. After leading man Atsumi Kiyoshi died, the residents and director Yamada decided to preserve the neighborhood's retro look so that Torasan wouldn't get lost when he returns home again. The various shops offer traditional Japanese snacks and cuisine, from *kusa dango* and *kuzumochi* to freshwater seafood. There truly is a romantic downtown feel to the neighborhood, and the people here are the most welcoming you'll find, like the beloved character of Torasan.

TAISHAKUTEN-DAIKYOJI

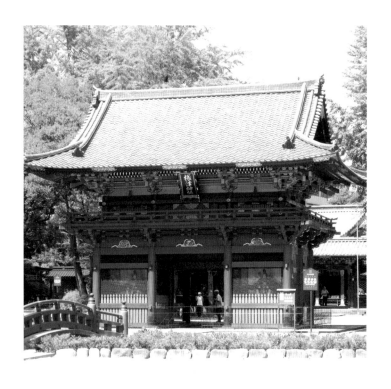

⓬ 根津神社（根津）

春のつつじ苑と乙女稲荷の千本鳥居も名高い根津神社。表参道口から楼門、唐門と進んでいくと、近所の子どもたちが鬼ごっこをして走り回り、水路の水面は緑を映じ、物語の世界に飛び込んだような趣だ。7000坪の深い緑に抱かれたこの地は徳川5代将軍綱吉の兄、甲府藩主・松平綱重の下屋敷跡で、将軍就任前に上州館林藩主だった綱吉との縁で、綱重がツツジの名所館林よりキリシマツツジを西側の岡に移植したのが苑の起こりという。由緒は千九百余年も遡り、日本武尊が千駄木の地に創祀と伝えられる古社。文明年間に太田道灌が社殿を奉建し、さらに1705（宝永2）年に綱吉が将軍世継を綱重の子、綱豊（後の6代将軍家宣）に定めると、綱豊誕生の松平家江戸屋敷地を献納し、社殿を奉建。翌年完成した権現造りの本殿・幣殿・拝殿・唐門・西門・透塀・楼門7棟はすべて欠けずに震災・戦災を免れて現存し、国の重要文化財に指定されている。

㉓ 6:00〜18:00（4・5・9・10月5:30〜、6-8月5:00〜、11-1月〜17:00、2・10月〜17:30、1/1 0:00〜19:00）授与所9:30〜17:30（2・10月〜17:00、11-1月〜16:30）㊝ 03-3822-0753 ㊡ 無休 ㊛ 文京区根津1-28-9 ㋐ 地下鉄千駄木駅・根津駅徒歩5分 ㋒ nedujinja.or.jp

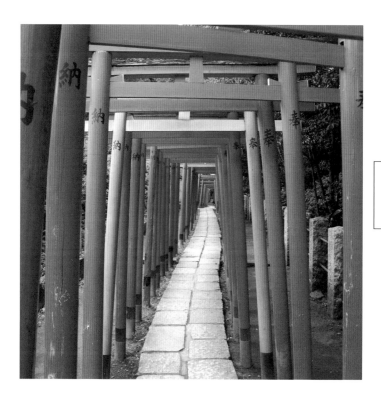

⑫ NEDUJINJA (Nezu)

Nezu Shrine is famous for its "thousand *torii* gates" and Otome Inari Shrine located on its grounds. The path from Omotesando passes the *romon* and *karamon* gates, and you can often spy children playing. The vibrant greenery above is reflected in the stream that runs through the shrine. The vast forest around the shrine is the site of Matsudaira Tsunashige's (Shogun Tokugawa Tsunayoshi brother) former residence. Nezu Shrine's history goes back nearly 1,900 years. It was founded in Sendagi by Yamato Takeru, according to legend. During the Bunmei era of 1469-87, Ota Dokan had a shrine erected there. In 1705, upon Tsunayoshi's selection of Tsunatoyo (Tsuneshige's son) as the 6th Tokugawa Shogun, the Matsudaira Residence grounds were dedicated to Nezu Shrine and more buildings were erected. The 7 structures built over the following year have all survived to this day and are designated Important Cultural Properties.

Ⓗ 6:00~18:00 (open 5:30 in Apr, May, Sep & Oct, 5:00 in Jun-Aug, closed 17:00 in Nov-Jan, 17:30 in Feb & Oct, 0:00~19:00 on Jan 1) / Shrine Office 9:30~17:30 (closed 17:00 in Feb & Oct, 16:30 in Nov-Jan) Ⓣ 03-3822-0753 Ⓒ Open Year-round Ⓐ𝒹 1-28-9 Nezu, Bunkyo-ku Ⓐ𝒸 5-min walk from Sendagi Metro Station / Nezu Metro Station Ⓤ nedujinja.or.jp

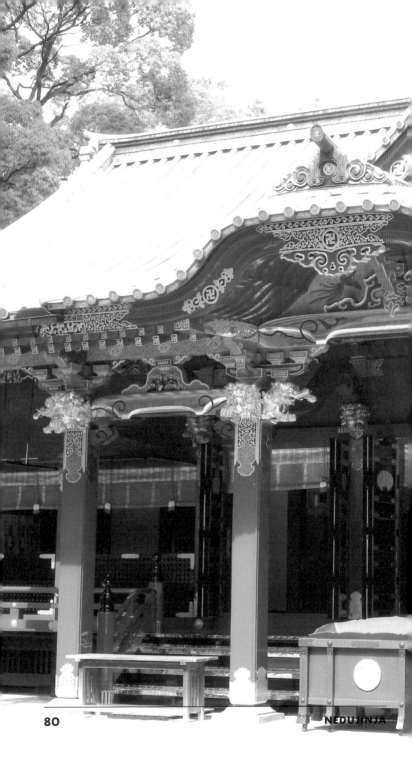

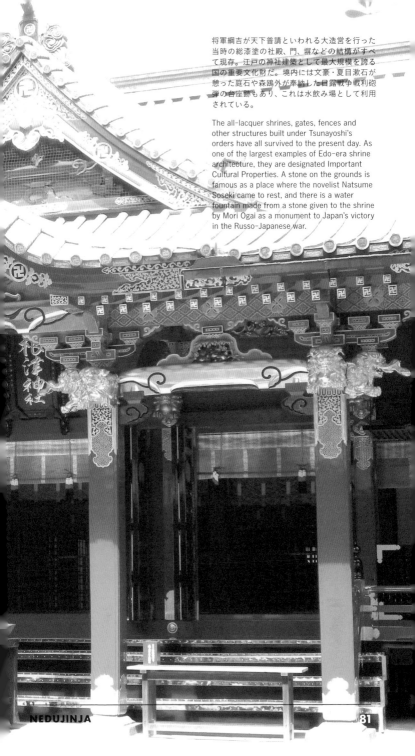

将軍綱吉が天下普請といわれる大造営を行った
当時の総漆塗の社殿、門、塀などの結構がすべ
て現存。江戸の神社建築として最大規模を誇る
国の重要文化財だ。境内には文豪・夏目漱石が
憩った庭園や森鴎外が奉納した日露戦争戦利砲
弾の台座跡もあり、これは水飲み場として利用
されている。

The all-lacquer shrines, gates, fences and
other structures built under Tsunayoshi's
orders have all survived to the present day. As
one of the largest examples of Edo-era shrine
architecture, they are designated Important
Cultural Properties. A stone on the grounds is
famous as a place where the novelist Natsume
Soseki came to rest, and there is a water
fountain made from a stone given to the shrine
by Mori Ogai as a monument to Japan's victory
in the Russo-Japanese war.

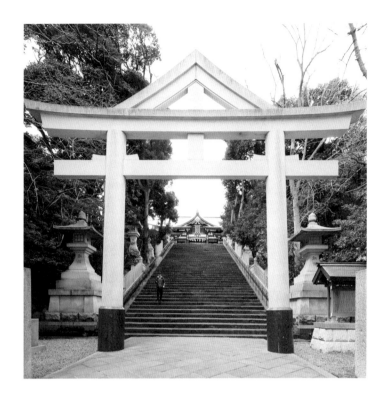

⓭ 日枝神社（赤坂）

皇居に正対する参道は、緑深い星ヶ岡の高台らしい風情で、かたや赤坂側参道はモダンなランドスケープをなして本殿へとアプローチ。日本の国政の中心、永田町の一角で皇城の鎮として要を護る日枝神社のご祭神は、『古事記』にある近淡海国の日枝山（比叡山）に鎮まった大山咋神、別名を山末之大主神。平安末に江戸氏が武蔵野開拓の祖神、江戸郷の守護神として館に山王宮を祀って歴史が始まり、さらに 1478（文明10）年に太田道灌公が江戸城築城に際し川越山王社を勧請。徳川家康公が居城とすると、将軍家の産土神と尊崇したことから、その祭礼・山王祭は神田祭と両天下祭・御用祭として城内と城下町を盛大に賑わす大祭になった。日本三大祭にも数えられ錦絵に多く描かれてきた山王祭は、江戸へのタイムスリップが体験できる。拝殿前に狛犬ならぬ山の守り神の神猿像が夫婦で並んでいて、日参してバナナを供えられるほど地元の崇敬も篤い。

時 5:00 〜 16:00（末社〜 15:00）　電 03-3581-2471　休 無休　住 千代田区永田町 2-10-5　ア 地下鉄赤坂駅・溜池山王駅徒歩 3 分　ウ hiejinja.net

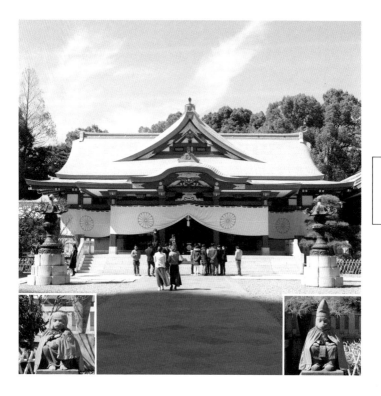

PART_3

⑬ HIE JINJA (Akasaka)

The *sando* facing the Imperial Palace offers a grand view of natural beauty, while the path coming from Akasaka shows a decidedly modern landscape. Hie Shrine is located in the political center of Japan, and therefore protects one of Japan's most vital areas. Oyamakuinokami, the god of Mt. Hie that appears in the *Kojiki*, is enshrined here. A man of the Edo clan is said to have established the first Hie Shrine at the end of the Heian period when he enshrined the guardian deity of the region then called Edo-go. In 1478, Ota Dokan built the Kawagoe Sanno Shrine as Edo Castle was being constructed. When Tokugawa Ieyasu came to live in the castle, he worshipped the shrine as guardian deity to the Shogun's family. For this reason, the procession of Sanno Festival, along with Kanda Festival, was specially permitted to proceed into the castle, making it one of the most important festivals in Edo. Seeing the Sanno Festival today is like going back in time to old Edo. The *masaru* monkey guardians in front of the shrine are never without a banana, offerings from local residents.

(H) 5:00~16:00 (subordinate shrine ~15:00) (T) 03-3581-2471 (C) Open Year-round (Ad) 2-10-5 Nagatacho, Chiyoda-ku (Ac) 3-min walk from Akasaka / Tameike-sanno Metro Station (U) hiejinja. net

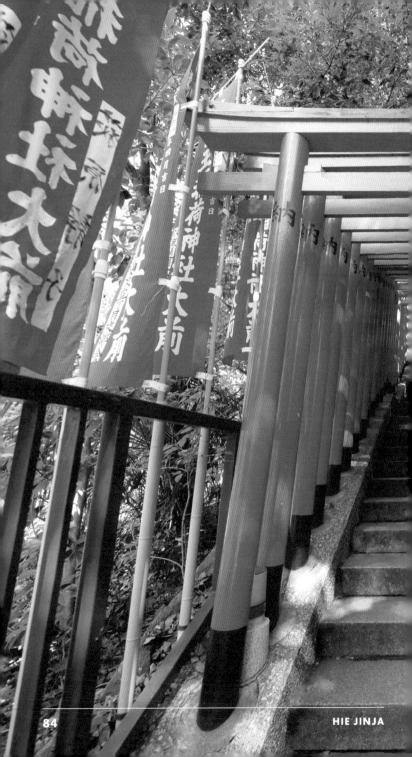

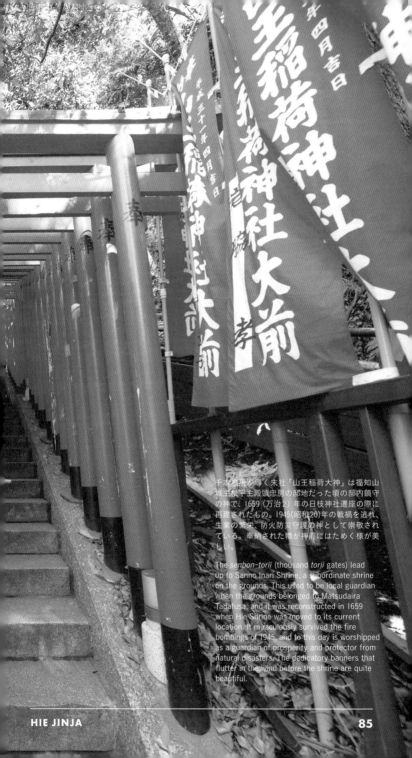

千本鳥居が導く末社「山王稲荷大神」は福知山
城主松平主殿頭忠房の邸地だった頃の邸内鎮守
の神で、1659（万治2）年の日枝神社遷座の際に
再建されたもの。1945(昭和20)年の戦禍を逃れ、
生業の繁栄、防火防災守護の神として崇敬され
ている。奉納された幟が神前にはためく様が美し
い。

The *senbon-torii* (thousand *torii* gates) lead
up to Sanno Inari Shrine, a subordinate shrine
on the grounds. This used to be local guardian
when the grounds belonged to Matsudaira
Tadafusa, and it was reconstructed in 1659
when Hie Shrine was moved to its current
location. It miraculously survived the fire
bombings of 1945, and to this day is worshipped
as a guardian of prosperity and protector from
natural disasters. The dedicatory banners that
flutter in the wind before the shrine are quite
beautiful.

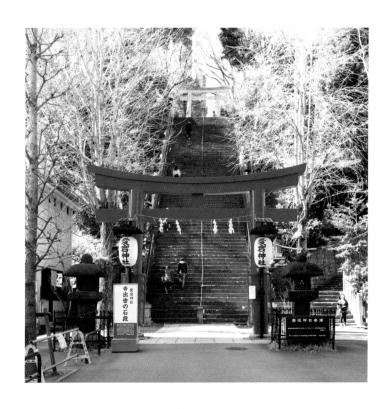

⑭ 愛宕神社（神谷町）

道路の英語標識に「Mt. Atago」とあるように、都会の真ん中ながら標高 25.7m と 23 区内随一の高さを誇る自然地形の山で、頂の境内には山の証の三角点（p87 左下）もある。江戸の昔から、芝浦、江戸湾、遥か房総の山々まで一望できた絶景スポットで、春は桜、夏は涼と蝉時雨、秋は月見に紅葉、冬は澄み渡る遠景と庶民に愛され、北斎、広重、国貞などの錦絵にその様子を残している。千日詣りのほおずき市、羽子板市の発祥もここ。愛宕神社は家康公が幕府を開くや江戸の防火の総鎮守として 1603（慶長 8）年に幕命で社殿を建立し、創建された。1860（万延元）年に水戸の浪士たちが神前祈念のあと、井伊大老を討ち、その目的を果たした桜田門外の変の集合場所でもあり、烈士の碑も。また 1868（慶応 4）年江戸城総攻撃 2 日前、勝海舟が官軍側の西郷隆盛を連れてきて江戸市中を見渡して会談し、無血で城で引き渡す決意の舞台ともなった。

㉔ 社務所 9:00 〜 17:00（臨時変更等 HP 参照） ㉔ 03-3431-0327 ㉔ 無休 ㉔ 港区愛宕 1-5-3 ㋐ 地下鉄神谷町・虎ノ門ヒルズ駅徒歩 5 分・虎ノ門駅・都営線御成門駅徒歩 8 分 �händ atago-jinja.com

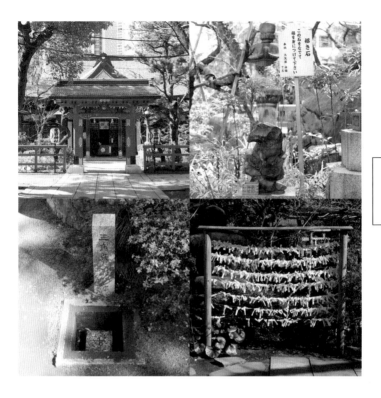

⑭ ATAGO JINJA (Kamiyacyo)

Signs along the road read "Mt. Atago" in English, the area being at an elevation of 25.7 meters, the highest in this district of Tokyo despite being in the center of the city. There is even a triangulation station at the top of this natural mountain (lower left). It has been a popular sightseeing spot for ages. The works of Hokusai, Hiroshige, and Kunisada depict the sakura in spring, the summer rain amidst cicada cries, moon-viewing amid autumn foliage, and the calm snowy landscape of winter. The *hozuki* and *hagoita* markets have their origins here as well. Atago Shrine was established by Tokugawa Ieyasu as a ward against fires which plagued Edo Japan. It is also famous as the place where the *ronin* samurai of the Sakuradamon Incident met and prayed before their assassination of Ii Naosuke. Be sure not to miss the famous *resshi no ishibumi* ("hero's monument"). The famous negotiations of the Fall of Edo in 1868 also took place here, ending with the peaceful surrender of the shogun to the Imperial army.

Ⓗ Office 9:00-17:00 (check the website for temporary changes) Ⓣ 03-3431-0327 Ⓒ Open Year-round Ⓐⓓ 1-5-3 Atago, Minato-ku Ⓐⓒ 5-min walk from Kamiyacho / Toranomon-hills Metro Station, 8-min walk from Toranomon Metro Station / Toei Line Onarimon Station Ⓤ atago-jinja.com

ATAGO JINJA **87**

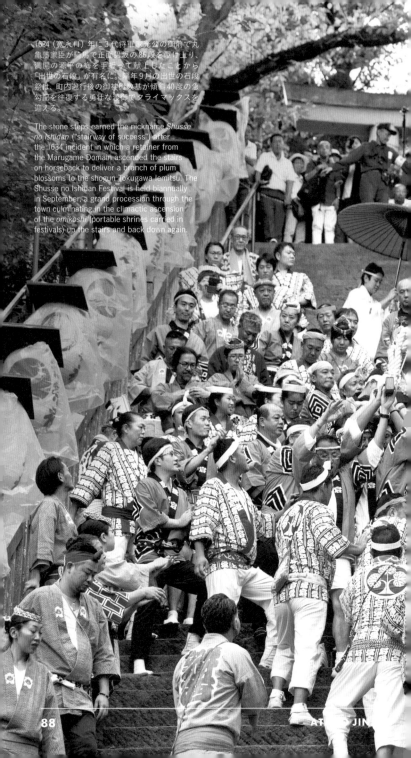

1634 (寛永11) 年に3代将軍家光公の御前で丸亀藩家臣が騎馬で正面男坂の85段を駆け上り、満開の源平の梅を手折って献上したことから「出世の石段」が有名に。隔年9月の出世の石段祭は、町内巡行後の御神輿94基が傾斜40度の急勾配を往復する勇壮な渡御でクライマックスを迎える。

The stone steps earned the nickname *Shusse no Ishidan* ("stairway of success") after the 1634 incident in which a retainer from the Marugame Domain ascended the stairs on horseback to deliver a branch of plum blossoms to the shogun Tokugawa Iemitsu. The Shusse no Ishidan Festival is held biannually in September, a grand procession through the town culminating in the climactic ascension of the *omikoshi* (portable shrines carried in festivals) up the stairs and back down again.

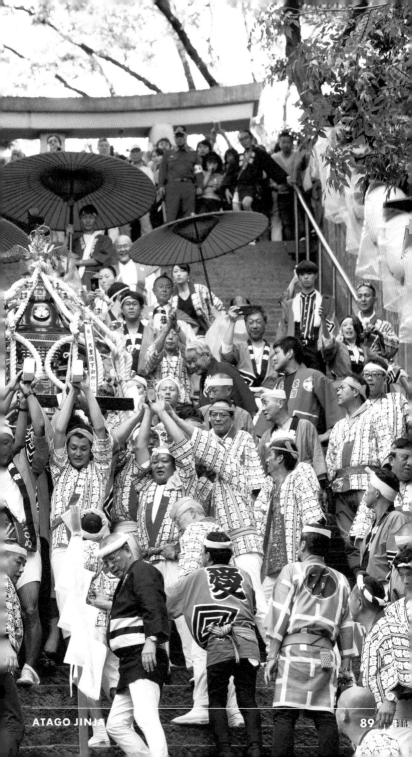

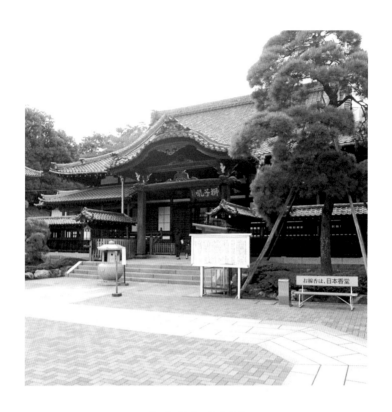

⑮ 泉岳寺（高輪）

武蔵野台地の東端、芝・高輪は徳川将軍家の菩提寺増上寺をはじめ、お寺の多い街。かつて東海道からの江戸の御府内の入口だった高輪は、すぐ脇は海で品川宿も近く、お参り＆物見遊山の名勝として賑わった。幕末期は海上艦との連絡が容易な立地条件から外国の公館も多く、泉岳寺前はイギリス公使館でもあった。泉岳寺は、もとは徳川家康が江戸開府して天下普請を進める1612（慶長17）年に、城に接する外桜田に門庵宗関和尚（今川義元の孫）を迎えて開山。諸国の僧侶約200名が参学し、曹洞宗江戸三ヵ寺、三学寮の一つとしても名を馳せた。寛永の大火（1641年）で焼失し、高輪にて再興した際に尽力した五大名のうちの一つが、赤穂藩主浅野家。1702（元禄15）年12月14日の赤穂事件の後、四十七義士の墓所としても知られ、歌舞伎「仮名手本忠臣蔵」の興行によって一層有名に。今日では外国人も墓前に手を合わせて賑わっている。

㉝ 4-9月 7:00〜18:00・10-3月 〜17:00。赤穂義士記念館 4-9月 9:00〜16:30・10-3月 9:00〜16:00
㉙ 赤穂義士記念館と義士木像館は共通券500円　㉘ 03-3441-5560　㉗ 無休　㉕ 港区高輪2-11-1
㉓ 都営線泉岳寺駅徒歩1分・JR高輪ゲートウェイ駅徒歩12分　㉖ sengakuji.or.jp

⓯ SENGAKUJI (Takanawa)

The Shiba and Takanawa districts of Tokyo are home to many temples, including the Tokugawa family temple Zojoji. Conveniently located near the sea, the area became home to many foreign residents after the end of the shogunate and the opening of Japan the world. Tokugawa Ieyasu established the temple near Edo Castle in 1612. Sengakuji soon became famous as one of the three great Soto sect temples of Edo, a place where over 200 monks came from around the country to study and practice. Destroyed in the great fire of 1641, it was reconstructed due to the efforts of five *daimyo* lords, including Lord Asano of the Ako Domain. The most famous Asano is Naganori, lord of the 47 *ronin* of the Ako Incident (1702). After this incident, Sengakuji Temple became even more famous as the gravesite of the 47 *ronin*, and the masterpiece of kabuki theatre *Kanadehon Chushingura* was based on their tale. Today, Japanese and foreigners alike can be seen paying their respects at the gravesite.

Ⓗ Apr-Sep 7:00~18:00, Oct-Mar ~17:00 / Ako Warriors Memorial Hall Apr-Sep 9:00-16:30, Oct-Mar 9:00~16:00 Ⓕ Ako Warriors Memorial Hall / Statue Exhibit combined fee ¥500 Ⓣ 03-3441-5560 Ⓒ Open Year-round Ⓐ�d 2-11-1 Takanawa, Minato-ku Ⓐc 1-min walk from Sengakuji Station, 12-min walk from JR Takanawa Gateway Station Ⓤ sengakuji.or.jp

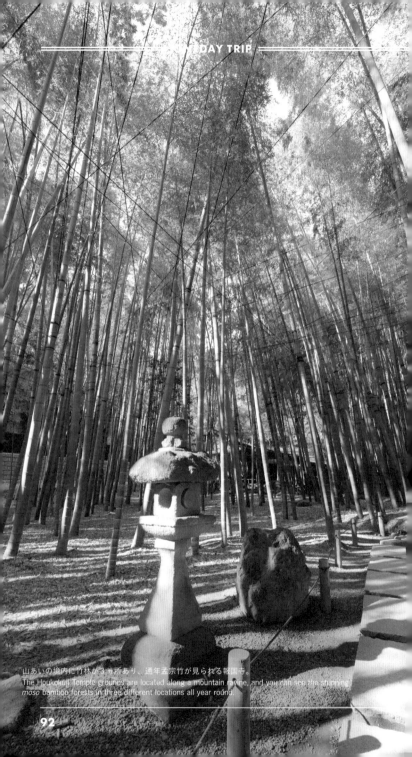

山あいの境内に竹林が3ヵ所あり、通年孟宗竹が見られる報国寺。
The Houkokuji Temple grounds are located along a mountain ravine, and you can see the stunning *moso* bamboo forests in three different locations all year round.

東京から1時間半、海と山に
抱かれた中世の城塞都市、古都鎌倉へ

南は海、そして山に囲まれる鎌倉は、源平合戦を通して源氏が武家政権を樹立し、幕府を開いて以降、歴史の舞台となる。禅宗文化が栄え、仏教美術も花開いた。そんな中世の城塞都市、鎌倉の貴重な遺構である切岸や切通し、掘割などは今も生活の中に溶け込んでいて、ふとしたカーブの坂道や生け垣などの風景から中世の時代へといざなってくれる。また山際に点在している"やぐら"と称される岩窟は古代の墳墓で、鎌倉の地に残る貴重な遺跡。こうした自然の遺産をそのまま擁して成る神社仏閣は、庭も四季折々美しく、また、山内の音の景色を楽しむこともできる。鎌倉時間は東京と同じではなく、場所によっては15時過ぎには山の陰に入るため、写真撮影重視派は陽の高いうちに訪れるのがおすすめ。早起きをして、いざ鎌倉と馳せ参じよう！

Kamakura, 1.5 Hours from Tokyo
A Town of the Middle Ages

Kamakura became an important historical location when the Minamoto Clan established the shogunate government in this city surrounded by mountains with the ocean to the south. Both zen culture and Buddhist art flourished here. The terrain modifications that were made to the city give the scenery a medieval feel that can surprise visitors with a sudden curve along a hilly road or an unexpected hedge. Scattered near the mountains of Kamakura are ancient tombs called "*yagura.*" The shrines and temples of Kamakura, which are built around and incorporate such magnificent historical features, are an excellent destination all year round. Dusk comes earlier here than in Tokyo, so visitors who want to take pictures will want to wake up bright and early!

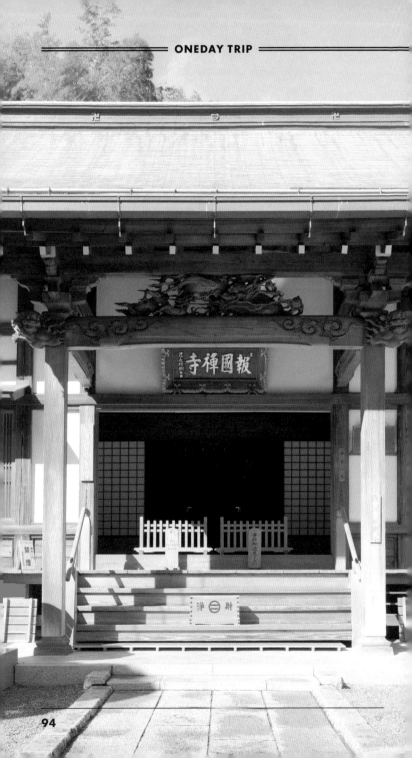

報国寺

創建は1334（建武元）年、ご開山は天岸慧広、勅諡号を仏乗禅師という。14歳で得度し、手にした東大寺、興福寺など6寺承認の国家の正式身分証、度牒、戒牒は現在も寺に伝わり、国の重要文化財だ。寺の開基は足利家時（尊氏祖父）で、上杉重兼も関わり、尊氏が室町幕府を開くと子息を鎌倉公方に据え、以来、禅宗文化が花開く鎌倉の地の東端で報国寺も足利・上杉の寺として寺容が整っていった。本堂（p94）のご本尊は釈迦如来座像。ご開山作の裏庭には約2000本の孟宗竹が生い茂り（p92）、茶席休耕庵では抹茶を喫して安らげる。

㊂ 9:00～16:00。日曜座禅会（参加自由）は7:30～10:30 ㊚ 竹庭拝観料300円。抹茶600円 ㊫ 0467-22-0762 ㊡ 無休。12/29～1/3閉門 ㊤ 鎌倉市浄明寺2-7-4 ㋐ JR鎌倉駅より京急バス浄明寺徒歩3分 ㋒ houkokuji.or.jp

HOUKOKUJI TEMPLE

Houkokuji was founded in 1334 by Tengan Eko. Eko became a monk at the age of 14, and his official certificates of *docho* and *kaicho* are Important Cultural Properties. Houkokuji was the family temple of both the Ashikaga and the Uesugi clans. After Ashikaga Takauji established the Muromachi Shogunate and placed his son as shogun, the temple flourished along with zen culture. The *honzon* (p.94) is a *shaka nyoraizo* statue, and behind the temple grow approximately 2,000 *moso* bamboo stalks (p.92). Visitors can enjoy matcha in the temple's teahouse, *Kyukoan*.

Ⓗ 9:00-16:00 / Sunday Meditation 7:30~10:30 Ⓕ Bamboo Forest entrance ¥300 / Matcha ¥600 Ⓣ 0467-22-0762 Ⓒ Open year-round except 12/29-1/3 Ⓐd 2-7-4 Jomyoji, Kamakura Ⓐc Keikyu bus from JR Kamakura Station to Jomyoji Stop, then 3-min walk Ⓤ houkokuji.or.jp

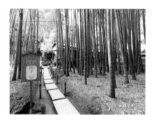

報国寺殿と呼ばれたご開基の家時から四代、勢威をふるい、関東の足利公方終焉の地ともなった。竹林の奥の庵ではお抹茶と豊島屋の落雁をいただける。

Houkokuji Temple, established by Ashikaga Ietoki, is known as the site of the end of Ashikaga's reign. Enjoy matcha and candy from Toshimaya in the teashop located through the bamboo forest.

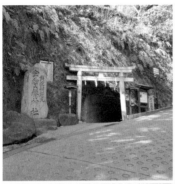

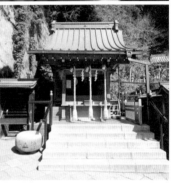

銭洗弁財天
宇賀福神社

巳年、巳の月、巳の日に頼朝公の夢枕
に立った隠里の主、宇賀神のお告げに
従い、仙境に岩窟を掘らせたのが起こ
り（上左）。線香、ローソクを本宮（下
右）に献じざるでお金を清める（上右）。
龍神（下左）では水神籤も楽しめる。

(時) 8:00 ～ 15:30　(料) 線香 & ざる 100 円　(電)
0467-25-1081　(休) 無休　(住) 鎌倉市佐助 2-25-
16　(ア) JR 鎌倉駅徒歩 25 分　(ウ) kanagawa-jinja.
or.jp

ZENIARAI BENTEN
UGAFUKU-JINJA

This shrine began when the god Ugajin
appeared before Minamoto no Yoritomo
in a dream and commanded that he
dig out the caves that house the shrine
(upper left). Visitors can dedicate
incense and candles (bottom right), wash
their money (upper right), and enjoy
mizumikuji.

(H) 8:00~15:30　(F) Incense & money-washing
sieve ¥100　(T) 0467-25-1081　(C) Open year-round
(Ad) 2-25-16 Sasuke, Kamakura　(Ac) 25-min walk
from JR Kamakura Station　(U) kanagawa-jinja.
or.jp

明月院

MEIGETSU-IN

平治の乱に散る首藤刑部大輔俊通を弔い創建。北条時頼・時宗が堂宇を建て、1380（康暦2）年、足利氏満の命で管領上杉憲方が中興。子院として残り、本堂・方丈（写真）は聖観世音菩薩を祀る。仏殿、鎌倉最大級のやぐら等、全域が国指定史跡。

Meigetsu-in honors Sudo Toshimichi who died in the Heiji Rebellion of 1160. Unkept for a time, it was restored in 1380. It is now a subordinate temple to the main temple which honors Sho Kannon. The grounds, including the largest *yagura* tombs in Kamakura, are designated Historic Sites of Japan.

(時) 9:00～16:00（6月8:30～17:00） (料) 500円 ※6月花菖蒲と12月紅葉期は「本堂後庭園」公開別途500円 (電) 0467-24-3437 (休) 無休 (住) 鎌倉市山ノ内189 (ア) JR北鎌倉駅徒歩10分 (ウ) kamakura-burabura.com

(H) 9:00~16:00 (Jun 8:30~17:00) (F) ¥500 *Jun and Dec: additional ¥500 for garden admission (T) 0467-24-3437 (C) Open year-round (Ad) 189 Yamanouchi, Kamakura (Ac) 10-min walk from JR Kitakamakura Station (U) kamakura-burabura.com

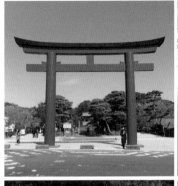

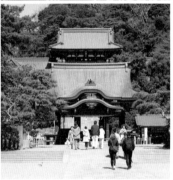

鶴岡八幡宮

源氏再興の旗上げをした源頼朝公は、後に由比ヶ浜辺の八幡宮をこの地に遷し、1191(建久2)年に上下両宮の姿(下右)に整えた。上左は海から続く若宮大路の三ノ鳥居。源平池の東の島、旗上弁財天社には願掛けの源氏の二引きの旗が。舞殿西側の奉納酒樽(下左)も神徳を物語る。

(時) 6:30～20:30 (料) 宝物殿200円。神苑ぼたん庭園500円 (電) 0467-22-0315 (休) 無休 (住) 鎌倉市雪ノ下2-1-31 (ア) JR鎌倉駅東口・江ノ電鎌倉駅徒歩10分 (ウ) hachimangu.or.jp

Tsurugaoka Hachimangu

Minamoto Yoritomo established both upper and lower halls (bottom right) in an effort to promote the renewed power of the Minamoto. The third *torii* can be seen from the road leading to the shrine from the sea (upper left). The dedicatory *sake* casks (lower left) also tell stories of divine virtue.

(H) 6:30~20:30 (F) Homotsuden ¥200 / peony garden ¥500 (T) 0467-22-0315 (C) Open year-round (Ad) 2-1-31 Yukinoshita, Kamakura (Ac) 10-min walk from JR Kamakura Station East Exit / Enoden Kamakura Station (U) hachimangu.or.jp

98

鎌倉で寄りたい2つのミュージアム
Two Must-see Museums of Kamakura

©Tsurugaoka Museum, Kamakura

鎌倉文華館
鶴岡ミュージアム

鎌倉国宝館

太鼓橋を越え平家池の前に現れるのは、坂倉準三建築の神奈川県立近代美術館・旧鎌倉館を継承し2019年開館した鶴岡八幡宮の新たな文化発信拠点。

⊕ 10:00〜16:30（入館〜16:00）料 各展示ごとHP参照 電 0467-55-9030 休 月曜（祝日の場合は開館）、展示替期間、年末年始 住 鎌倉市雪ノ下2-1-53 ア JR鎌倉駅東口・江ノ電鎌倉駅徒歩10分 ウ tsurugaokamuseum.jp

運慶が造ったとされる十二神将像を模した仏像など鎌倉期に頂点を極める仏師らの至宝を社寺より預かる市立の美の殿堂。

⊕ 9:00〜16:30（入館〜16:00）料 300円〜 電 0467-22-0753 休 月曜（祝日の場合は開館）、展示替期間、年末年始 住 鎌倉市雪ノ下2-1-1（八幡宮境内）ア JR鎌倉駅東口・江ノ電鎌倉駅徒歩12分 ウ city.kamakura.kanagawa.jp/kokuhoukan/

TSURUGAOKA MUSEUM

KOKUHOUKAN MUSEUM

Past the *Taiko*-bashi Bridge before the Heike Pond you'll find a splendid building built by Sakakura Junzo. Tsurugaoka Museum is the shrine's newest facility (est. 2019).

Ⓗ 10:00~16:30 (No entrance after 16:00) Ⓕ Check the website for detailed info on each exhibit Ⓣ 0467-55-9030 Ⓒ Closed Mondays (except holidays), during exhibit changes, year-end and new year holidays Ⓐⓓ 2-1-53 Yukinoshita, Kamakura Ⓐⓒ 10-min walk from JR Kamakura Station / Enoden Kamakura Station Ⓤ tsurugaokamuseum.jp

This museum displays a variety of exquisite Kamakura-period art, including a collection of sculptures of the Twelve Divine Generals modelled after the work of Unkei.

Ⓗ 9:00~16:30 (No entrance after 16:00) Ⓕ ¥300 Ⓣ 0467-22-0753 Ⓒ Closed Mondays (except holidays), during exhibit changes, year-end and new year holidays Ⓐⓓ 2-1-1 Yukinoshita, Kamakura Ⓐⓒ 12-min walk from JR Kamakura Station / Enoden Kamakura Station Ⓤ city.kamakura.kanagawa.jp/kokuhoukan/

高徳院

鎌倉といえば大仏様。高徳院の本尊、国宝銅造阿弥陀如来坐像（あみだにょらいざぞう）は、作者は不明だが、運慶とそれに連なる仏師たち、慶派の作風と宋代中国の仏師たちからの影響の双方を併せ持つ鎌倉期らしい仏像ともいわれている。北条得宗家の正史『吾妻鏡』（あずまかがみ）によれば、造立の開始は1252（建長4）年、僧浄光（じょうこう）が勧進した浄財が当てられたと伝わる。が、その大仏殿はのちの台風や大津波のために倒壊してしまい、室町時代の末までには今の露坐の大仏に。像高約11.3m、重量約121t。ほぼ造立当初の像容を保つ大仏様は仏教東伝の象徴でもある。20円でご胎内入場可。

(時) 4-9月 8:00〜17:30、10-3月〜17:00（入場は閉門15分前まで）。大仏胎内拝観〜14:20 (料) 300円。大仏胎内拝観料20円 (電) 0467-22-0703 (休) 無休 (住) 鎌倉市長谷4-2-28 (ア) 江ノ電長谷駅徒歩10分 (ウ) kotoku-in.jp

KOTOKU-IN

You can't mention Kamakura without mentioning the *Daibutsu* statue, a national treasure and *honzon* of Kotoku-in Temple. Though the author is unknown, it is believed to be a Kamakura-period work. Temple construction began in 1252, but the hall originally sheltering the *daibutsu* was destroyed by subsequent typhoons and tsunamis. By the end of the Muromachi period, the great statue sat outdoors as it is today. Approximately 11.3 meters high and weighing 121 tons. Preserved since its construction centuries ago, it is a testament to Buddhism in the East.

(H) Apr-Sep 8:00~17:30, Oct-Mar ~17:00 (admission stopped 15 minutes before closing)/no admission to Daibutsu after 14:20 (F) ¥300 / ¥20 to enter Daibutsu statue (T) 0467-22-0703 (C) Open year-round (Ad) 4-2-28 Hase, Kamakura (Ac) 10-min walk from Enoden Hase Station (U) kotoku-in.jp

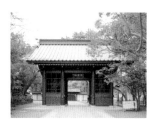

18世紀初頭の移築と伝わる山門（左）の仁王門に山号「大異山」（だいいさん）の扁額がかかる。創建当初の大仏像を収めていた堂宇の礎石60基のうち境内に56基残る一つ（右）。

The plaque on the *niomon* gate (left) reads "*Daiisan*." 56 of 60 foundation stones that supported the former hall that housed the *daibutsu* still remain (right).

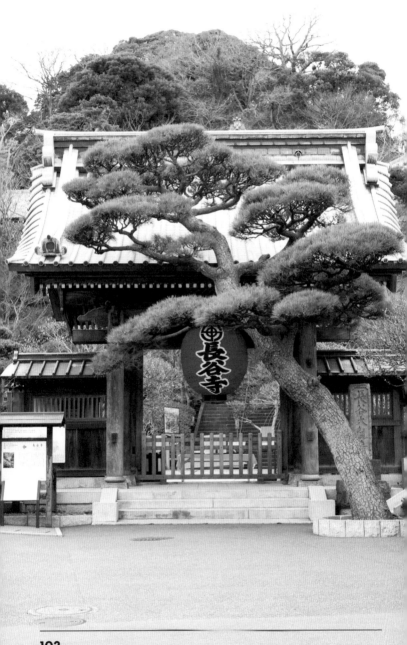

長谷寺

長谷寺は奈良時代の736（天平8）年開創、寺伝に曰く、聖武天皇の御代より勅願所と定められた鎌倉有数の古刹だ。本堂のご本尊、十一面観音菩薩像は像高三丈三寸（9.18m）にも及ぶ日本最大級の木彫仏で、721（養老5）年、大和（奈良県）長谷寺のご開山の本願を基に仏師らが彫り、造顕されたうちの一体。開基藤原房前（鎌足の孫）により鎌倉に遷座され、開創の礎となった。観音山の裾野から中腹に境内が広がり、由比ヶ浜はもとより三浦半島や相模湾を見渡せる鎌倉随一の見晴台では、幕府を置いた源頼朝に思いを重ねることもできる。

（時）3-9月 8:00〜17:00（閉山17:30）、10-2月〜16:30（閉山17:00）。観音ミュージアム 9:00〜16:00。写経・写仏 9:00〜15:00 （料）400円。観音ミュージアム300円。 （電）0467-22-6300 （休）無休 （住）鎌倉市長谷3-11-2 （ア）江ノ電長谷駅徒歩5分 （ウ）hasedera.jp

HASEDERA

Hasedera Temple was established in 736, making it one of the oldest temples in Kamakura. The principle object of worship, a 9.2-meter 11-faced Kannon, is the largest wooden sculpture in Japan. It is said to be one of the statues dedicated to Hasedera in Yamato (Nara Prefecture) in 721. The temple grounds offer an unparalleled view of the Miura Peninsula, Sagami Bay and Yuigahama, and many visitors find themselves in a reverie, thinking nostalgically of Minamoto no Yoritomo who established the first shogunate in Kamakura.

(H) Mar~Sep 8:00~17:00 (closed 17:30), Oct~Feb~16:30 (closed 17:00) / Kannon Museum 9:00~16:00 / sutra copying 9:00~15:00 (F) ¥400/Kannon Museum ¥300 (T) 0467-22-6300 (C) Open year-round (Ad) 3-11-2 Hase, Kamakura (Ac) 5-min walk from Enoden Hase Station (U) hasedera.jp

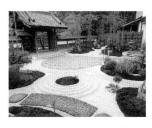

ご本尊は本堂の観音堂（左）で拝見できる。隣接の観音ミュージアムでは、寺宝の展示や観音信仰について分かりやすく解説している。（右）枯山水庭園が美しい書院。

The *honzon* is inside Kannon-do Hall (left). Temple treasures are on display in the Kannon Museum next door (right), as well as useful explanations regarding the faith of Kannon.

PART_4

お参りプラスアルファを楽しむ

SHRINES AND TEMPLES WITH A LITTLE EXTRA

参拝とともに精進料理や喫茶、
骨董探しなどのエンタメ要素も嬉しい社寺

神社仏閣といえば、粛とした気持ちで参拝し、感謝や祈りを捧げる聖なる場所。そして、お参りを済ませると、どこか心が安らいで、晴れやかな気持ちになるもの。そんな時、すぐに帰るのも名残惜しくて、ちょっと寄り道をしたい気分になりませんか。ここでは、クロスカルチャーな都市・東京ならではの、お参りプラスアルファの楽しみがある社寺へご案内。例えば、東京タワーから眼下に東京を見下ろして高得点を祈ったり、その麓のテラスで僧侶のお手製のお菓子に舌鼓を打ったり、本物の精進料理を体験できたり、人気の授与品を探したり、あるいは期間限定の演劇や見世物にドキドキしたり、参道に佇むおばあちゃんが営む駄菓子屋さんで懐かしいおやつを見つけたり。賑わう景色も眼福、と笑顔になるはず。

Enjoy Traditional Buddhist Cuisine, Cafes, and Antiques Shopping While Visiting These Magnificent Shrines and Temples

Shrines and temples are often associated with a solemn and subdued atmosphere where visitors are offer prayers and gain a sense of calm and contentment. While this is generally true, many visitors may not want to just go home afterward. On the contrary, you may want to explore nearby sightseeing spots. In this chapter, we introduce shrines and temples that have something extra to offer visitors in the multicultural city of Tokyo. At Tokyo Tower, for example, you can offer prayers while looking down upon the sprawling city, enjoy delicious handmade confections offered by monks on the bottom terrace, experience authentic *shojin-ryori* (Buddhist vegetarian cuisine), search for popular talismans and charms, watch seasonal shows and exhibits, and find the many traditional candy shops run by *obaachan* (elderly ladies) along the approach to the shrine. The lively scenery here never fails to bring a smile to the face.

ARTRIP ADVISER	2017年10月スタートの書籍シリーズ「TOKYO ARTRIP」の編集チーム。日本茶、和菓子、建築、和骨董、日本酒、喫茶店とすでに6タイトルが揃う。7号になる本書、神社仏閣では、お参りはもちろん、エンターテイメント性のある場所を吟味する。
TOKYO ARTRIP 「トーキョー・アートリップ」 編集チーム 'TOKYO ARTRIP' editors	Tokyo Artrip Series Editorial Team (since 2017). This seventh installment of Tokyo Artrip is on shrines and temples, covering sacred sites that offer an entertainment factor that other temples and shrines may not have.

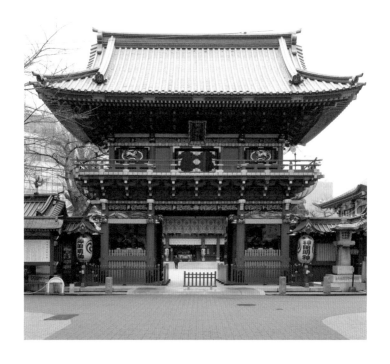

⑯ 神田明神（神田）

徳川家康公が天下分け目の関が原の戦いに臨む際に神田明神の神職に戦勝祈祷し、見事勝利。その 1600（慶長5）年9月15日が神田祭であったことも大いに喜ばれ、篤く崇敬を受けて江戸総鎮守と称えられた。神田・日本橋・秋葉原・大手町・丸の内の氏子108町の総氏神として崇敬される神田明神の神田祭は、まさに江戸東京を代表する壮麗さで、天下祭、御用祭とも称されている。730（天平2）年に今の皇居大手門脇将門塚周辺に大己貴命を奉祀して創建され、ご祭神は3柱。だいこく様（縁結び）、えびす様（商売繁昌）、まさかど様（厄除）。お参り後は境内左手の文化交流館 EDOCCO の中にある SHOP「IKIIKI」で多摩産ひのき御朱印帳（3080円、p.107左上）等のオリジナル商品、「CAFE MASUMASU」で神社声援＆マシュマロの縁結びセット（555円、同右下）等も楽しめる。アニメやゲームとのコラボも有名で聖地と詣でるファンも多数訪れる。

㈬ 授与所 9:00～18:00（季節により変動あり）　☎ 03-3254-0753　㈹ 無休　㈲ 千代田区外神田 2-16-2　㋐ JR 御茶ノ水駅徒歩5分・秋葉原駅徒歩7分、地下鉄御茶ノ水駅・新御茶ノ水駅・末広町駅徒歩5分　㋒ kandamyoujin.or.jp

⑯ KANDAMYOUJIN (Kanda)

Tokugawa Ieyasu prayed at Kanda Myoujin before the great Battle of Sekigahara, leading to his victory and ultimately the establishment of the Tokugawa shogunate. Kanda Festival was held on September 15 of that year (1600), a happy coincidence that led Ieyasu to praise Kanda Shrine as the guardian deity of Edo. Kanda Festival is one of the most representative festivals of Tokyo, held in honor of the guardian deities of the Kanda, Nihonbashi, Akihabara, Otemachi, and Marunouchi districts. Onamuchi-no-mikoto was enshrined in 730 near the what is now the site of Taira no Masakado's grave, and the shrine now houses 3 deities: Daikoku, Ebisu and Masakado. Drop into Ikiiki (within the Edocco Culture Complex) to check out a variety of original goods including *hinoki* cypress *goshuincho* (¥3,080, p.107 upper left), booklets used for collecting official shrine and temple stamps. You can also enjoy refreshments at Cafe Masumasu (¥555, lower right). The shrine is also considered a sacred site to anime and game lovers who come from far and wide to visit.

Ⓗ Juyosho (amulet receiving office) 9:00~18:00 (subject to seasonal changes) Ⓣ 03-3254-0753
Ⓒ Open year-round Ⓐⓓ 2-16-2 Sotokanda, Chiyoda-ku Ⓐⓒ 5-min walk from JR Ochanomizu Station, 7-min walk from Akihabara Station Ⓤ kandamyoujin.or.jp

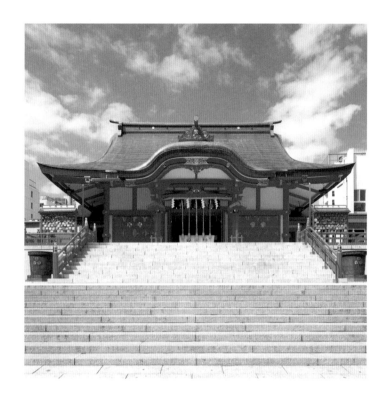

⓱ 花園神社（新宿）

流行に高感度な百貨店、歌舞伎町の歓楽街、訪日観光客にも人気の小さな飲み屋がひしめくゴールデン街、区役所、高層ビル群と、まさに多様性ワールド・新宿。その総鎮守こそが花園神社。銀杏のご神木とともに江戸開府以前から内藤新宿を見守り、その盛況ぶりは毎週日曜日に開かれる青空骨董市や春、夏の劇団による野外公演でもうかがえる。なかでも、新宿の夜の街を煌々と照らして一層活気づかせるのが、関東三大酉の市の一つ、山の手随一といわれる大酉祭（酉の市）。花園神社に合祀する大鳥神社のご祭神である日本武尊の命日、11月の酉の日に行われ、毎年露店で商売繁昌の開運熊手を買って、縁起を担ぐのが江戸っ子の師走を迎える風物詩。酉の市の日には、境内にあふれるほどの参拝者が訪れ、妖しい看板や客寄せの口上も健在な最後の見世物小屋一座・大寅興行社による約20分のビックリショー（p.109）が名物。演目を変え深夜まで公演されて賑わっている。

(時) 社務所 8:00 〜 20:00　(料) 酉の市の見世物小屋入場料は後払い制 800 円　(電) 03-3209-5265
(休) 無休　(住) 新宿区新宿 5-17-3　(ア) 地下鉄新宿三丁目駅徒歩 0 分・JR 新宿駅東口徒歩 7 分　(ウ)
hanazono-jinja.or.jp

⑰ HANAZONO SHRINE (Shinjuku)

Shinjuku is truly a variegated landscape of grand skyscrapers, department stores, bars and government offices. The guardian shrine of this entire area is Hanazono Shrine. The sacred ginkgo tree has stood with the shrine to watch over Shinjuku's Naito district since before the Edo shogunate. Come to the Sunday antiques market or the outdoor plays put on in the spring and summer. One event you won't want to miss is the great Otori Festival, the largest *tori no ichi* fair in the Yamanote area. Otori Shrine, on the same grounds, celebrates the mythical hero Yamato Takeru's birthday on the day of the rooster (*tori no hi*) in November. This fair's nostalgic atmosphere brings to mind the image of *edokko* ("children of Edo") celebrating the coming of December. On the day of the *tori no ichi* fair the shrine is flooded with visitors, suspicious-looking signboards and vendors vying for customers. You can even watch a surprise show (above) put on by Japan's last freak show producer Otora Kogyo-sha. The 20-minute shows alternate between different acts and continue until late at night.

Ⓗ Office 8:00~20:00　Ⓕ Freak show ¥800 (charged after show)　Ⓣ 03-3209-5265　Ⓒ Open year-round　Ⓐd 5-17-3 Shinjuku, Shinjuku-ku　Ⓐc 0-min from Shinjuku Sanchome Metro Station, 7-min walk from JR Shinjuku Station East Exit　Ⓤ hanazono-jinja.or.jp

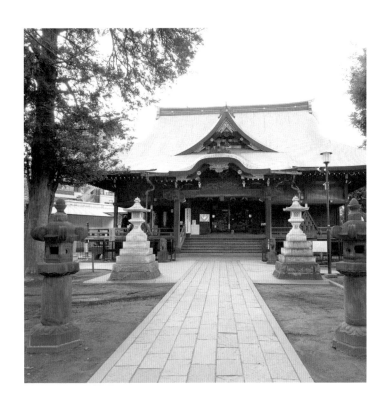

⓲ 雑司ヶ谷鬼子母神堂（雑司が谷）

平安朝の昔からあった鬼子母神信仰。そもそも鬼子母神とはインドの夜叉神の娘で、訶梨帝母と呼ばれ、千人の子を産むも近隣の幼児を食べ、恐れ憎まれていた。そこでお釈迦様が帝母の末の子を隠すと帝母は過ちを悟り、安産・子育の神となると誓って尊崇されるようになったという。室町時代に雑司の役にあった武士がご尊像を掘り出し、霊験あらたかゆえに安土桃山時代の1578（天正6）年、稲荷の森と呼ぶ地に村人が堂宇を建て、この社が新築遷座して雑司ヶ谷鬼子母神堂に。日蓮宗寺院の法明寺の飛び地境内で、江戸時代の姿が復元されたお堂は国指定重要文化財でもある。参道には、ジブリ映画のモデルにもなったノスタルジックな駄菓子屋さんがある (p.111)。店主の内山雅代さんがきなこ飴やミルク煎餅などを商い、ひっきりなしに、親子、カップル、近所の学生たちが来店。「梅ジャム！」「今、酢イカは値上げしたの」などと沸いていた。

㊞ 9:00〜17:00（参道の駄菓子屋上川口屋は 10:00-17:00）　㊞ 03-3982-8347　㊞ 無休　㊞ 豊島区雑司が谷 3-15-20　㊞ 地下鉄雑司が谷駅徒歩 5 分、JR 池袋駅東口徒歩 15 分、目白駅徒歩 15 分　㊞ kishimojin.jp

⑱ ZOSHIGAYA KISHIMOJIN-DO
(Zoshigaya)

The faith of Kishimojin has survived since the Heian period. Originally, Kishimojin, also called "Kariteimo," was the feared daughter of an Indian *yaksha* warrior demon who birthed a thousand children but abducted and ate the children of others. When the Shakyamuni Buddha hid her youngest from her, however, she realized the error of her ways and came to be revered as goddess of safe birth and childrearing. During the Muromachi period, a warrior uncovered a sacred statue that would later become the *honzon* of this temple. In 1578, a new temple was erected in a site called *Inari no Mori* ("forest of Inari"), where the statue was enshrined, establishing the Zoshigaya Kishimojin-do. A branch of Homyoji Temple sect is also located here, its restored building now a designated Important Cultural Property. Along the *sando* you'll find the *dagashiya* (pictured above) selling *kinako ame* (candy) and milk *senbei* (rice crackers) that was famously used as a model by the Ghibli animation studio. Shop manager Masayo Uchiyama is never without customers.

Ⓗ 9:00~17:00 (Kamikawaguchiya *dagashi* shop 10:00~17:00) Ⓣ 03-3982-8347 Ⓒ Open Year-round Ⓐⅾ 3-15-20 Zoshigaya, Toshima-ku Ⓐⅽ 5-min walk from Zoshigaya Metro Station, 15-min walk from JR Ikebukuro Station East Exit / Mejiro Station Ⓤ kishimojin.jp

⑲ 神谷町光明寺（神谷町）

2階の本堂前にあるテラスは、目の前に東京タワーが迫り、昼時には大使館や外資系企業の多い近隣からコーヒーやお弁当を手に人々が集まり、思い思いに過ごしている。驚くなかれ、春から秋の水・金曜は光明寺の僧侶・木原祐健さんが丹精したお菓子や飲み物をいただくことができ（無料、予約優先）、本堂での読経を聞くこともできる。「この試みから、お寺が培ってきた『おもてなし』の心を皆様にもお伝えできれば」と木原さん。1540（天文9）年の疫病流行の際に本尊の阿弥陀如来像が光明を放って人々を救った縁起のある光明寺には、徳川家康入府の折に住職が境内の紅梅に古歌を添えて献上したことを家康が喜んだこと、後に三代将軍・家光が訪問の折に祖父・家康とのご縁を喜び、山号を「梅上山」と改めたことなどの故事が伝わる。僧侶による傾聴活動も行っており、都会のオアシスのような場所になっている。

㋑ 平日9:00〜17:00（参詣、施設利用は予約不要）、おもてなしは4〜10月・水・金曜11:00〜14:00（1回50分、〜4名）、傾聴は毎月曜（共に無料・HPより要予約）　㋱ なし　㋬ 土・日・祝（臨休あり）　㋐ 港区虎ノ門3-25-1　㋐ 地下鉄神谷町駅徒歩1分　㋒ komyo.net/kot/

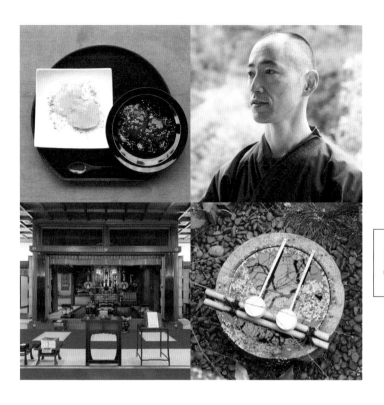

⑲ KOMYOJI TEMPLE TOKYO (Kamiyacho)

The terrace is always crowded in the afternoon with embassy officials and local office workers enjoying lunch and the view of Tokyo Tower. Visitors can receive refreshments made by priest Yuken Kihara on Wednesdays and Fridays from spring through autumn (free, priority given to reservations) amid the echo of sutra readings from the *hondo*. Mr. Kihara tells us, "It is my hope that this conveys the temple's *omotenashi* (hospitality)." It is said that Komyoji's *honzon* saved the people from the pestilence of 1540. It is also said that Tokugawa Ieyasu received an apricot tree and an ancient poem from the head priest, and that his grandfather renewed the temple's mountain name to "Baijozan" when he visited, in honor of the temple's connection to the Tokugawa family. The monks offer consultations to visitors as well, making Komyoji an oasis amid the bustle of Tokyo.

Ⓗ 9:00~17:00 Weekdays (reservations unnecessary for general worship and use of facilities), *Omotenashi* service Apr–Oct (Mon-Wed-Fri) 11:00~14:00 (50-min, up to 4 participants), Consultation with priests held Mondays (free, reservation via HP required) Ⓣ None Ⓒ Sat, Sun, Holidays (subject to temporary closures) Ⓐ𝖽 3-25-1 Toranomon, Minato-ku Ⓐ𝖼 1-min walk from Kamiyacho Metro Station Ⓤ komyo.net/kot/

⑳ 三光院（小金井）

堂々たる山門の奥に、蝋梅や黒椿などの茶花が趣を湛える中庭が広がり、本堂へ。さらに脇の石畳を進むと十月堂があり、京都・嵯峨野の尼門跡、曇華院の流れを受け継ぐ竹之御所流精進料理が楽しめる。インドに始まり、北方の大乗仏教の流れから日本に伝わった仏教。その精進料理は奈良、平安、鎌倉と各時代に発展を遂げて伝えられてきたが、この中には天皇家の皇女や王女が入寺した比丘尼御所、尼門跡と称される男子禁制の寺院のものも春秋を重ね護られてきた。足利義材将軍時代に幕府も置かれた尼寺五山の一、通玄寺の精進料理は、その法灯を受け継ぐ子院で竹之御所の号を賜る曇華院が継承。その禅尼を武蔵野の地に招いて開山したのが三光院だ。竹之御所流精進料理を供する3代目後継者は、フランス料理出身の尼、西井香春料理長。お煮しめや香の物も簡素ながら雅で、山紫水明の日本の水と畑の恵み、禅と御所の心が尽くされている。

⊙ 精進料理の予約が入っている時のみオープン、精進料理は12:00〜　⊛ 精進料理は花（一汁五菜 3500円）、月（一汁六菜 4600円）、雪（一汁七菜 5800円）の3コース、要予約　☎ 042-381-1116　⊗ 毎月曜・第3水曜・第4金曜　⊕ 小金井市本町3-1-36　⊘ JR武蔵小金井駅徒歩15分　⊚ sankouin.com

⑳ SANKOUIN (Koganei)

Enter the temple gate and pass through the beautiful garden, lush with spices and flowers that will flood the senses. Continue along a stone-paved path and you'll find Jugetsudo Hall where you can enjoy the traditional vegetarian cuisine of *Take no Gosho Shojin-ryori*. This cuisine began in India and was brought to Japan with Mahayana Buddhism. *Shojin-ryori* developed over the Nara, Heian, and Kamakura periods. The practice was notably transmitted through *bikuni-gosho* temples which forbade men and into which imperial princesses were known to cloister themselves. The *Shojin-ryori* of Tsugenji Temple was continued at its subordinate temple Dongein (*Take no Gosho*), from which a nun was summoned to establish Sankouin Temple. Chef Koshun Nishii, who studied French cuisine, is the third successor of the *Take no Gosho Shojin Ryori* tradition. Her boiled and pickled vegetables are simple yet elegant, boons of nature elevated to art and infused with zen.

Ⓗ Only open when *Shojin-ryori* is offered, 12:00~　Ⓕ *Shojin-ryori, hana* ¥3,500 / *tsuki* ¥4,600 / *yuki* ¥5,800 (all courses require reservation)　Ⓣ 042-381-1116　Ⓒ Every Monday, 3rd Wednesday, 4th Friday　Ⓐ𝒹 3-1-36 Hon-cho, Koganei　Ⓐ𝒸 15-min walk from JR Musashi Koganei Station Ⓤ sankouin.com

都内の精進料理が楽しめるお寺リスト

高尾山薬王院（高尾）

標高 599mの高尾山は老若男女に登りやすく、日本一の急勾配31度18分を運行しているケーブルカーの乗降者数だけでも年間250万人以上、紅葉の季節には1時間も待つ人気の山だ。仏ミシュランが初の日本版旅行ガイド本で富士山と並んで3つ星の観光地に選んだこともあり、高尾山は都心から気軽に行ける山として近年ますます行楽客を迎え、なかでも山中に風致を添えている薬王院の諸堂はメインのデスティネーションとして賑わっている。744（天平16）年に高僧・行基（ぎょうき）が開山し、1375（永和元）年に山岳信仰の飯縄（いづな）大権現を祀り、中興。修験道山伏が命を感謝する食の作法、一汁一菜から発達した精進料理を提供し、日本料理を極めた坂本和巳料理長が旬の野菜と大豆製のマグロ、レバー、牛しぐれ、ハム、鯖などの擬（もど）き料理とともに折々の味覚を楽しませてくれる。3種あり高尾膳3900円・天狗膳2900円は要予約、そば御膳1900円は予約不要。

(時) 精進料理 11:00 〜 14:00（高尾膳・天狗膳は前日までに要予約）　(電)042-661-1115（受付 8:30 〜 16:30）　(休) 無休　(住) 八王子市高尾町 2177　(ア) 京王線高尾山口駅より、登山ケーブル高尾山駅徒歩 20 分　(ウ) takaosan.or.jp

赤坂寺庵（てらん）（赤坂）

東京のお寺で学べる精進料理教室がある。赤坂アークヒルズなどの高層ビルが建ち並ぶビジネス街の中心にある方廣山常國寺（ほうこうざんじょうこくじ）は、ごま豆腐や飛龍頭（ひりょうず）などの日常で楽しめる精進ごはんをコンセプトにした各教室を開いている。初めてで不安な人も、旬の食材で3品試作して他2品と試食できる通常クラスの毎月の精進料理コースへの参加が可能。この体験レッスンは入会金不要で材料費込み 9000円を事前払いすれば、エプロン・ふきん・筆記用具を持参するだけ。常國寺は江戸時代前期の1661（寛文元）年に今の日比谷桜田門・祝田橋（いわいだばし）周辺に創建された貞教庵が、のちに江戸城拡張のため溜池を望む今の高台、霊南坂に移って号を改め、三百有余年の法灯を護り続けている。本尊は阿弥陀如来（あみだにょらい）。衆徒で管理栄養士の浅田昌美理昌（りしょう）さんが、命と向き合う精進料理を作り食べるという体験を通して、生きる力を身につける「育自力（いくじりょく）」の大切さを伝えている。

(時) 精進料理教室 毎月第 2・第 3 の火・木・土曜（法要等により不定期）10:30 〜 13:30　(料) 各受講料は HP 参照　(電)03-3587-1498　(休) 各スケジュールは HP 参照　(住) 港区赤坂 1-11-4　(ア) 地下鉄溜池山王駅徒歩 13 分　(ウ) akasaka-teran.net

TEMPLES THAT OFFER SHOJIN CUISINE

TAKAOSAN YAKUOIN (Takao)

The steepest railway line in Japan, the cable car leading up to Mt. Takao, takes 18 minutes to reach the top, though at 599 meters the mountain is easily scalable. The cable car sees over 2,500,000 passengers per year, and visitors wait in line for over an hour in autumn when the leaves are the most stunning. It was given 3 Michelin stars along with Mt. Fuji, and has enjoyed immense popularity as a tourist spot in recent years, the main destination being Yakuoin Temple, which structures are nestled elegantly among the mountain scenery. High Priest Gyoki established the temple in 744, and it was restored in 1375, when the deity Izuna Daigongen was enshrined. A simple *shojin-ryori*, with roots in the practice of *shugendo*, is offered here, featuring the wonderful imitation meats created by master chef Katsumi Sakamoto. Three courses are offered: Takao-zen (¥3,900, reservation only), Tengu-zen (¥2,900, reservation only), and Soba-gozen (¥1,900 no reservation required).

(H) *Shojin-ryori* 11:00~14:00 (Takao-zen and Tengu-zen courses require reservation at least one day in advance) (T) 042-661-1115 (8:30-16:30) (C) Open year-round (Ad) 2177 Takaocho, Hachioji (Ac) Cable car from Keio Line Takaosanguchi Station to Takaosan Station, then 20-min walk (U) takaosan.or.jp

AKASAKA TERAN (Akasaka)

This cooking school offers *shojin-ryori* classes on the Jokokuji Temple grounds. The temple offers classes on various accessible forms of *shojin-ryori*, such as sesame tofu and *hiryozu* (fried tofu mixed with slices of vegetables) amidst the grand skyscrapers of Akasaka. For beginners, we recommend the standard class offered every month, where you will attempt 3 dishes using seasonal ingredients, and are allowed to sample 2 other dishes that are professionally made. This trial lesson costs ¥9,000, which includes the cost of all ingredients. All you need to bring is an apron, dishtowel and writing instrument. Jokokuji was originally established under the name Teikyoan in the Hibiya Sakuradamon area (1661), but was moved and renamed due to the expansion of Edo Casle. The *honzon* is an image of *Amida Nyorai*. Buddhist practitioner and dietitian Masami Asao Risho uses her *shojin-ryori* classes to teach the importance of self-improvement.

(H) *Shojin-ryori* 2nd and 3rd Tue, Thu, and Sat of the month 10:30~13:30 (F) Check HP for details (T) 03-3587-1498 (C) Check HP for details (Ad) 1-11-4 Akasaka, Minato-ku (Ac) 13-min from Tameike Sanno Metro Station (U) akasaka-teran.net

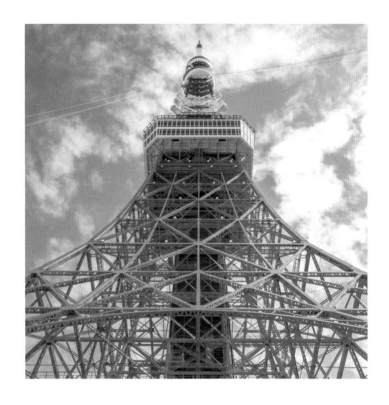

㉑ タワー大神宮（芝公園）

東京23区内で最も高所の神社に参詣するなら、東京タワー展望台へ入場を。1階からエレベーター45秒で高さ150m、世界有数のメトロポリスの全方位パノラマを展望できるメインデッキ2階に到着し、この一角に清浄な白木の社がある。六本木から南方の丘陵は、かつてすぐ先は波打ち際で、今も大和の前方後円墳がある芝公園の一帯は、伊勢神宮へ神饌を調進する荘園・飯倉御厨として歴史書『吾妻鏡』や伊勢神宮領地一覧『神鳳鈔』に登場している。岸辺に1394（応永元）年に創祀された鎮守は、今の東京タワー麓に遷座した幸稲荷神社。徳川家光将軍の時に御府内古跡十三社に列せられ、明治の神仏分離後は増上寺山内の神社を多数合祀している東京でも最も古い祠の一つだ。その幸稲荷神社が御奉仕しているタワー大神宮は、1958（昭和33）年竣工当時、高さ世界一の333mの電波塔、東京タワーの開業20周年に創建され、富士山も望むここで天照皇大神を祀っている。

⊕ 9:00～23:00（最終入場～22:30）ⓡ 展望台入場料150mメインデッキ1200円（150m & 250mトップデッキツアーはWEB予約2800円・当日3000円）☎ 03-3433-5111 ⑭ 無休 ⑪ 港区芝公園4-2-8 ⑦ 都営線赤羽橋駅徒歩5分 ⑨ tokyotower.co.jp

❷❶ GREAT SHINTO SHRINE OF THE TOWER (Shibakouen)

Climb up Tokyo Tower to visit the highest Shinto shrine in Tokyo. On the main deck, at a height of 150 meters, you can see a panoramic view of one of the world's greatest metropolises. Tucked away in a corner is a shrine made of unadorned wood. The hill south of Roppongi was once a waterfront. The Shiba Park area is referred to in ancient texts such as *Azuma Kagami* and *Jinposho* as a supplier of dedicatory food and drink to Ise Shrine called Iikura Mikuriya. Saiwai Inari Jinja was built on the riverbank in 1394 but was later relocated to the foot of Tokyo Tower. One of 13 shrines remaining from the time of Tokugawa Ieyasu, it is the oldest in Tokyo, since many shrines were combined after the Meiji-era separation of Buddhism and Shintoism. The Great Shrine of the Tower, a branch of Saiwai Inari Jinja, was built in 1978, 20 years after Tokyo Tower was completed. The shrine looks out upon Mt. Fuji and enshrines the sun goddess Amaterasu Omikami.

ⓗ 9:00~23:00 (No entrance after 22:30) ⓕ Entrance to observation platform main deck (150m) ¥1,200/150 & 250m top deck tour ¥2,800 with online res., ¥3,000 day-of ⓣ 03-3433-5111 ⓒ Open year-round ⓐⓓ 4-2-8 Shibakouen, Minato-ku ⓐⓒ 5-min walk from Akabanebashi Station ⓤ tokyotower.co.jp

巡冨 じゅんぷう JUNFU

身代り御守 MIGAWARI OMAMORI

新しい財布にするときに入れたい手のひらサイズの薄紙で作られた金運お守り。お財布供養もあり。五百羅漢寺 (p.26) 500円

A lucky charm placed inside new wallets for luck in finance. Temple also offers prayer services for discarded wallets. Gohyaku Rakanji (p.26) ¥500

身代わって守ってくれる。干支とその守護神の梵字入り、法輪（教義）入りの2種類。高幡山明王院金剛寺 (p.16) 全7色 各500円

Lucky charms against misfortune. Two varieties: zodiac & Sanskrit letters, or Buddhist teachings. Kongoji (p.16) 7 colors, ¥500/each

厄除うちわ YAKUYOKE UCHIWA

高得点 KOTOKUTEN

煩悩を焼くお護摩の火は不動明王の智慧の象徴。願いを清めて成就。1/1～2/3のみの授与品。高幡山明王院金剛寺 (p.16) 500円

The fire depicted burns away human suffering, and is a symbol of Fudo Myo-o's wisdom. Only offered from 1/1 to 2/3. Takahata-Fudoson Kongoji (p.16) ¥500

東京タワートップデッキの旧特別展望台が特展と呼ばれたことから、高得点のゲンを担ぐ開運守。タワー大神宮 (p.118) 250円

Tokyo Tower's top deck was also called "Tokuten," which can mean "to score." Thus, Kotokuten, or "high score" charms were created. Tokyo Tower (p.118) ¥250

だるまみくじ DARUMA MIKUJI

寅さん守り TORASAN MAMORI

七転び八起きの縁起のいいだるまさん。底におみくじが入っていて引くのが楽しい。紅白揃う。愛宕神社 (p.86) 500円

Daruma dolls are associated with the saying "fall 7 times, get up 8." These daruma come with *omikuji*. Atago Shrine (p.86) ¥500

生まれも育ちも葛飾柴又、名は寅次郎。旅先でマドンナと恋に落ち、ふらりと帰る寅さんの必需品。帝釈天題経寺 (p.72) 1000円

A charm carried by the beloved character Torasan, born and raised in Shibamata. Kaishakuten Daikyoji (p.72) ¥1,000

学業成就鉛筆

受験生に、転がっても落ちない四角形の学業成就鉛筆はHBの格言入り・格言無し各6本、1ダース。湯島天満宮 (p.52) 700円

GAKUGYO-JOJU PENCILS

These pencils are designed not to "fall off" the table, and also not to "fail" tests taken by the user. Includes 1 dozen pencils, 6 with wise sayings, 6 without. Yushima Tenmangu (p.52) ¥700

降魔札 (ごうまんが)

室内用の33体の魔滅 (まめ)(豆) 大師 (だいし) と戸口に貼る室外用の角大師 (つのだいし) 2枚の魔除けのお札が紙に包まれている。深大寺 (p.10) 500円

GOMAFUDA

Wooden planks wrapped in paper to ward off evil spirits. One type is placed indoors, while the other is placed at the doorway. Jindaiji Temple (p.10) ¥500

まさる守 (まもり)

日枝大神の遣い、お猿さんがキュート。厄除け、魔除け、夫婦円満などを祈るお守り。日枝神社(p.82) 赤白2色 大600円、小500円

MASARU-MAMORI

Cute monkey *omamori* that ward off evil and bring harmony to couples. Hie shrine (p.82) ¥600 (L) / ¥500 (S)

国家安穏お守り

純白に桜花の柄と色糸で細長い日本地図、日の丸、裏に国家安穏の文字と赤玉の織り柄。護国寺 (p.34) 500円

KOKKA-ANNON OMAMORI

One side shows cherry blossoms, a map of Japan and the rising sun, the characters for *kokka annon* ("peace for the country") on the other. Gokokuji (p.34) ¥500

絵馬 ジブリ式神版 (しきがみ)

神田明神でジブリ展が開かれた2019年より発売されたコラボ絵馬。映画『千と千尋の神隠し』の式神版。神田明神 (p.106) 1500円

GHIBLI *SHIKIGAMI* EMA

Developed for the Ghibli exhibit at Kanda Myoujin (p.106) in 2019. Based on *shikigami* that appear in *Spirited Away*. ¥1,500

勝守 (かちまもり)

徳川家康公が関ヶ原の合戦にこの勝守を授かり勝利を得たことから勝負、取引等に御神徳あり。神田明神 (p.106) 500円

KACHIMAMORI

Charm carried by Tokugawa Ieyasu in the Battle of Sekigahara, which led to his victory. It brings good fortune in business. Kanda Myoujin (p.106) ¥500

GLOSSARY（用語集）

Amida (or Amitabha) Buddha – the celestial Buddha of Mahayana scripture, and the primary deity of Pure Land Buddhism.

Ashikaga period – 1336-1573. Also known as the Muromachi period.

Asuka period – 538-710

Buddhism – an ascetic religion that originated in ancient India in the 5th to 4th century BCE through the teachings of the "Buddha" or "enlightened one," believed to be Siddhartha Gautama.

Chinese zodiac – a cycle of twelve animals used to classify years in ancient China and Japan as part of the sexagenary cycle.

Danjiki – ascetic fasting. This term also refers to a type of Buddhist image seen at temples: Buddhist practitioners who observed ascetic fasting until they became one with Buddha.

Daruma – also called "daruma dolls," these round, hollow papier mache dolls are modelled after the Bodhidharma, founder of the Zen Buddhism.

Edo period – 1603-1868

Ema – votive pictures (traditionally of a horse) dedicated at Shinto shrines in Japan along with wishes, prayers, or messages of gratitude.

Ennichi – days of religious significance to a shrines and temples.

hagoita – a wooden paddle used to hit balls resembling shuttlecocks in an ancient game called *hanetsuki*.

Hatsumode – the first shrine visit of the year.

Heian period – 794-1185

hondo – the "Main Hall" of a temple which houses the *honzon*.

honzon – the primary object of worship at a Buddhist temple, often the image of the titular Buddha of that temple.

Jodoshu /Jodo Shinshu – Both Jodoshu ("Pure Land Sect") and Jodo Shinshu ("Pure Land New Sect") are sects of Buddhism in Japan which believe in the Amida Buddha who promised rebirth in the Pure Land to those who believe in him. Jodo Shinshu is the largest sect of Buddhism in Japan.

Kamakura period – 1185-1333

kami – deities of the Shinto religion, often associated with natural phenomena (mountains, rivers, etc).

kumade – literally "bear's hand," this term refers to a type of bamboo rake. A miniature version of the *kumade* is sold as an amulet meant to bring good luck.

Lotus Sutra – one of the most important sutras of Mahayana Buddhism.

Mahayana Buddhism – one of two main branches of Buddhism (the other being Theravada), Mahayana is the form that came to Japan around the mid sixth century CE.

Mamemaki – the Setsubun tradition of throwing beans about the house or at temples and shrines while chanting "in with fortune, out with demons."

matsuri – festivals held in Japan since ancient times. Some are of Shinto origin, some of Buddhist, and still others may be secular.

Meiji period – 1868-1912

mizuya – a ritual water basin at which worshippers purify their hands and mouths before appearing before the *kami* at a Shinto shrine. Also called "*chozuya*" or "*temizuya*."

Momoyama Period – 1568-1600. Also known as Azuchi-Momoyama period.

Muromachi period – 1336-1573. Also known as the Ashikaga period.

Nara period – 710-794

omamori – lucky amulets sold at shrines and temples, coming in different colors representing different forms of luck (luck in study, relationships, finance, etc).

omikuji – lots that tell the holder's fortune, from *daikichi* (great fortune) to *daikyo* (great misfortune).

sando – the path leading up to a Shinto shrine or a Buddhist temple.

sanmon – one of the most important gates in a Buddhist temple, often leading to the main hall.

Sengoku period – Literally "age of warring states." The sengoku period was a time of nearly constant civil war from 1467 to 1615, though some place the end of the period as early as 1590.

Setsubun – the day that marks the end of winter and the beginning of spring, an important holiday in Japanese culture.

sexagenary cycle – a sixty-part cycle, consisting of a combination of ten "stems" and twelve "branches," which was used in the measure of time (both years and days) in ancient China and Japan.

Shakyamuni Buddha – Siddhartha Gautama, the historical Buddha and originator of the religion of

Buddhism (5th–4th century BCE).

Shichifukujin – the "seven lucky gods" of Japanese mythology: Ebisu (patron god of fishermen), Daikokuten (commerce and prosperity), Bishamonten (war), Benzaiten (arts), Jurojin (longevity), Hotei (happiness), Fukurokuju (wisdom).

Shinto – Japan's native spiritual belief system which worships natural phenomena (mountains, rivers, etc) as deities called *kami*.

Showa period – 1926–1989

Shrine – a sacred building or collection of buildings that houses *kami* (gods) of Japan's Shinto religion.

sutra – the general term for sacred texts of the Buddhist tradition.

Sokushinbutsu – Buddhist practitioners who observed ascetic practices culminating in mummification while still alive. Sokushinbutsu are one of the many types of Buddhist images that can be seen at temples.

Taisho period – 1912–1926

Temple – a sacred building or collection of buildings where Buddhists practice their faith.

Zen – a sect of Buddhism in Japan, the most famous practice of which is *zazen*.

zazen – a form of seated meditation practiced in Zen Buddhism.

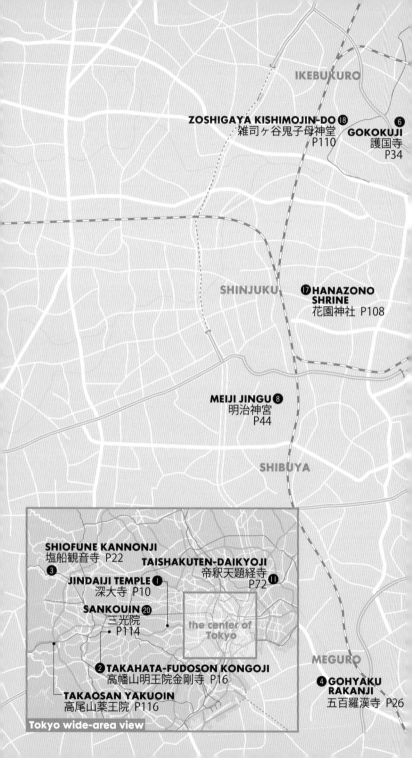

IKEBUKURO

ZOSHIGAYA KISHIMOJIN-DO ⑱
雑司ヶ谷鬼子母神堂
P110

⑥
GOKOKUJI
護国寺
P34

SHINJUKU

⑰**HANAZONO
SHRINE**
花園神社 P108

MEIJI JINGU ⑧
明治神宮
P44

SHIBUYA

SHIOFUNE KANNONJI
塩船観音寺 P22

❸

TAISHAKUTEN-DAIKYOJI
帝釈天題経寺

JINDAIJI TEMPLE ❶
深大寺 P10

P72 ⑪

SANKOUIN ⑳
三光院
P114

the center of
Tokyo

❷ **TAKAHATA-FUDOSON KONGOJI**
高幡山明王院金剛寺 P16

MEGURO

TAKAOSAN YAKUOIN
高尾山薬王院 P116

❹ **GOHYAKU
RAKANJI**
五百羅漢寺 P26

Tokyo wide-area view

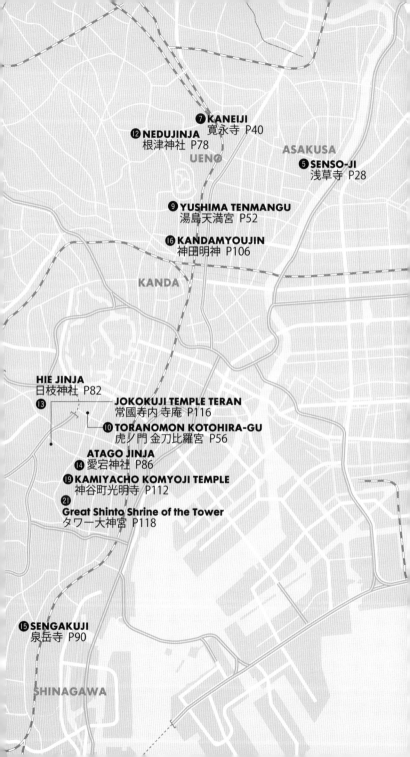

❼ KANEIJI
寛永寺 P40

⓬ NEDUJINJA
根津神社 P78

UENO

ASAKUSA

❺ SENSO-JI
浅草寺 P28

❾ YUSHIMA TENMANGU
湯島天満宮 P52

⓰ KANDAMYOUJIN
神田明神 P106

KANDA

HIE JINJA
日枝神社 P82

⓭

JOKOKUJI TEMPLE TERAN
常國寺内 寺庵 P116

❿ TORANOMON KOTOHIRA-GU
虎ノ門 金刀比羅宮 P56

ATAGO JINJA
⓮ 愛宕神社 P86

⓳ KAMIYACHO KOMYOJI TEMPLE
神谷町光明寺 P112

㉑

Great Shinto Shrine of the Tower
タワー大神宮 P118

⓯ SENGAKUJI
泉岳寺 P90

SHINAGAWA

TOKYO ARTRIP

神社仏閣

発行日　2020 年 7 月 31 日　第 1 刷

美術出版社書籍編集部編

カバーイラストレーション：NORITAKE
デザイン：TUESDAY（戸川知啓 + 戸川知代）
マップ：山本眞奈美（DIG.Factory）
撮影：大友洋祐（pp.10〜25、pp.44〜51、pp.56〜57、pp.72〜77、pp.82〜87、pp.92〜96、p.98、pp.100〜103、pp.106〜107、pp.110〜113、pp.120〜121）、森安照（pp.114〜115）、タオミチル（ミチル日々、pp.60〜69）
取材・文：武位教子（pp.60-69 を除く）、瀬戸道世（pp.60-69）
翻訳：クリストファー・ザンブラーノ
校正：みね工房（日本語）、アーヴィン香苗（英語）
編集：碓井美樹（美術出版社）

印刷・製本：シナノ印刷株式会社
発行人　遠山孝之、井上智治
発行　株式会社美術出版社
〒 141-8203 東京都品川区上大崎 3-1-1 目黒セントラルスクエア 5 階
Tel. 03-6809-0318（営業）　03-6809-0542（編集）
振替　00110-6-323989
https://www.bijutsu.press

ISBN 978-4-568-43118-6 C3070
© BIJUTSU SHUPPAN-SHA CO., LTD. 2020
Printed in Japan
禁無断転載

TOKYO ARTRIP

SHINTO SHRINES AND BUDDHIST TEMPLES

The First Edition Published on July 31,2020

Cover Illustration: NORITAKE
Designer: TUESDAY (Tomohiro+Chiyo Togawa)
Map: Manami Yamamoto (DIG.Factory)
Photographer: Yosuke Otomo (pp.10-25, pp.44-51, pp.56-57, pp.72-77, pp.82-87, pp.92-96, p.98, pp.100-103, pp.106-107, pp.110-113, pp.120-121), Akira Moriyasu (pp.114-115), Tao Michiru (Michiru Hibi, pp.60-69)
Writer: Kyoko Takei (except pp.60-69), Michiyo Seto (pp.60-69)
Translator: Christopher Zambrano
Proofreader (Japanese): Mine Kobo
Proofreader (English): Kanae Ervin
Editorial Director: Miki Usui (BIJUTSU SHUPPAN-SHA CO., LTD.)

Printing and Binding: Shinano Printing Company, Limited
Publishers: Takayuki Toyama, Tomoharu Inoue
Published by BIJUTSU SHUPPAN-SHA CO., LTD.
MEGURO CENTRAL SQUARE 5F, 3-1-1 Kamiosaki, Shinagawa-ku, Tokyo 141-8203 Japan
Tel. 03-6809-0318（Sales）　03-6809-0542（Editorial）
Transfer account　00110-6-323989
https://www.bijutsu.press

ISBN 978-4-568-43118-6 C3070
© BIJUTSU SHUPPAN-SHA CO., LTD. 2020
Printed in Japan
All rights reserved